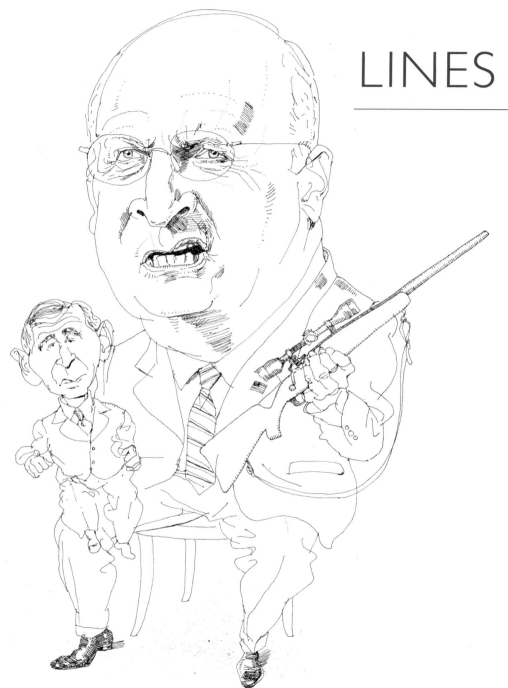

LINES OF ATTACK

Conflicts in Caricature

Edited by Neil McWilliam

Nasher Museum of Art

Duke University | 2010

Published in conjunction with the exhibition *Lines of Attack: Conflicts in Caricature*, organized by the Nasher Museum of Art at Duke University and curated by Neil McWilliam, the Walter H. Annenberg Professor of Art & Art History in the Department of Art, Art History & Visual Studies at Duke University.

Nasher Museum of Art at Duke University February 4, 2010–May 16, 2010.

Nasher Museum of Art at Duke University
2001 Campus Drive, Durham,
North Carolina 27705
(919) 684–5135
www.nasher.duke.edu

Cataloguing-in-publication data are available from the Library of Congress
Library of Congress Control Number applied for
ISBN: 0-938989-32-5
Distributed by Duke University Press

This exhibition, *Lines of Attack: Conflicts in Caricature*, catalogue, and related programs were sponsored in part by the Duke University Provost's Common Fund, the Sunny Rosenberg Endowment Fund, and the Sandra A. Urie and Katherine Urie Thorpe Endowment Fund.

Nasher Museum exhibitions and programs are generously supported by the Mary Duke Biddle Foundation, Mary D.B.T. Semans and the late James H. Semans, The Duke Endowment, the Nancy Hanks Endowment, the K. Brantley and Maxine E. Watson Endowment Fund, the James Hustead Semans Memorial Fund, the Marilyn M. Arthur Fund, the Victor and Lenore Behar Endowment Fund, the Sarah Schroth Fund, the Margaret Elizabeth Collett Fund, the North Carolina Arts Council, the Office of the President and the Office of the Provost, Duke University, and the Friends of the Nasher Museum of Art.

Copyediting by Eileen McWilliam,
 Chapel Hill, North Carolina
Printing and binding by Harperprints,
 Hendersonville, North Carolina
Book design by Bonnie Campbell,
 Durham, North Carolina
Typeset in Monotype Joanna

FRONT COVER/TITLE PAGE: Joe Ciardiello, *Dick and Dummy*, 2007. Copyright 2008 Joe Ciardiello.

BACK COVER: Charles Philipon, *Le Replâtrage* (Replastering). *La Caricature* No. 35, pl. 70, 30 June 1831. Mount Holyoke College Art Museum, South Hadley, Massachusetts.

Contents

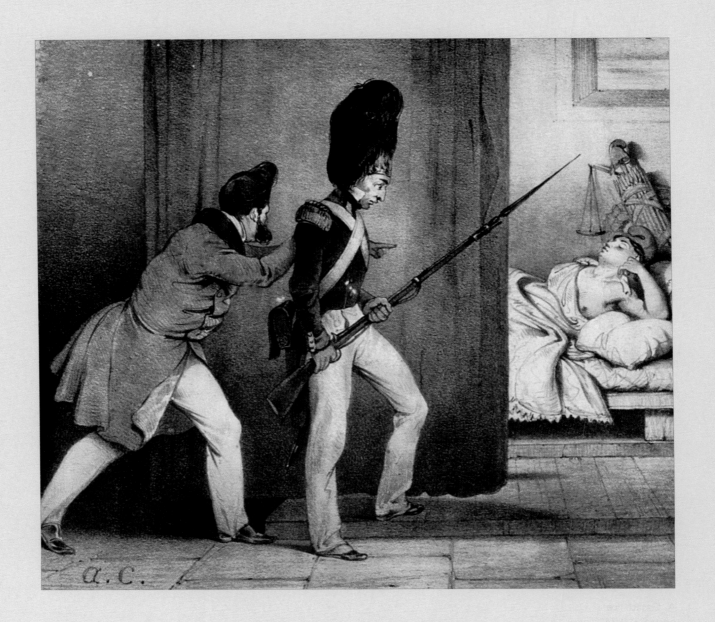

". . . the job of the cartoonist is to be against the government, whatever it is."[1] —PAT OLIPHANT

THE NASHER MUSEUM OF ART at Duke University is pleased to present *Lines of Attack: Conflicts in Caricature*, an exhibition that examines the state of political caricature at two pivotal moments: at its inception within a journalistic setting in 1830s France, when the invention of new printmaking techniques made it possible to present such images to a more or less mass audience; and in the very recent past, during the presidency of George W. Bush, at a moment when printed news sources, which have traditionally carried such political cartoons, are faced with unprecedented competition from a vast panoply of electronic media.

This project is the result of several years of research by Neil McWilliam, the Walter H. Annenberg Professor of Art and Art History at Duke University, working with a team of students from Duke and the University of North Carolina at Chapel Hill. They have chosen these two moments in history, and these two national leaders, Louis-Philippe in France and George W. Bush in the United States, not to denigrate or glorify them, but to focus on broader issues through the lens of political caricatures created around these two powerful figures, each of whom presided at a critical moment for the history of this graphic genre. Our project is political, but not partisan. Rather, the exhibition examines—and encourages visitors to examine—the graphic and representational techniques that create and convey meaning in a politicized visual domain accessible to broad audiences.

The Nasher Museum of Art at Duke University is most grateful to Professor McWilliam for his far-ranging exploration of this vast and complicated topic, and for his willingness to distill his research into the format of our exhibition and catalogue. We also thank his students, Corina Apostol, Ruthie Chen, Alexis Clark, and Katherine de Vos Devine of Duke University, and Katherine Arpen, Alison Hafera Cox, and Mara West of the University of North Carolina at Chapel Hill, for the tremendous energy and enthusiasm they have brought to the project, and for their thoughtful catalogue essays. Anne Schroder, the Nasher's Curator and Academic Program Coordinator, very capably served as coordinating curator for the project, and oversaw every detail with her customary skill and attention. She and I are both grateful to the Nasher Museum staff, who as always managed the myriad aspects of presenting such a project with tremendous dedication; we especially thank curatorial assistants Renee Cagnina and Carolina Cordova, registrars Myra Scott and Kelly Woolbright, and chief preparator and exhibition designer Brad Johnson. We also thank Durham Academy intern Jung Won Hwang for her assistance.

The Nasher Museum is also immensely grateful to our lenders, who responded generously to our requests, often for multiple works. We thank the Mount Holyoke College Art Museum, and curator Wendy Watson, curatorial assistant Rachel Beaupre, and registrar Linda Best; the Metropolitan

A. Casati, French, active 1820s and 1830s. *Parodie du tableau de la Clytemnestre* (Parody of the painting "Clytemnestra"), 1834. Lithograph, 8¼ × 8 ³⁄₁₆ inches. *La Caricature*, No. 168, pl. 353, 23 January 1834. Mount Holyoke College Art Museum, South Hadley, Massachusetts, 1991.10.1.

Museum of Art, and George R. Goldner, the Drue Heinz Chairman of the Department of Drawings and Prints, and curator Constance McPhee; the Jane Voorhees Zimmerli Art Museum at Rutgers, The State University of New Jersey, and director Suzanne Delehanty and curator Christine Giviskos; and the Beinecke Rare Book & Manuscript Library at Yale University, and curator Louise Bernard. We are also grateful to special collections librarian Sarah Shoemaker of the Robert D. Farber University Archives and Special Collections Library at Brandeis University for providing digitized images of additional Daumier prints for the exhibition.

Many thanks to our generous private lenders, including Susan Conway Gallery, Richard and Janet Caldwell, and Simon Powell. We also extend our special gratitude to the many artists who participated in the exhibition, generously provided information, and lent their original drawings and designs for political cartoons: Nick Anderson, Steve Bell, Khalil Bendib, Dwayne Booth (Mr. Fish), Steve Brodner, Joe Ciardiello, John Cuneo, Jeff Danziger, Matt Davies, Ken Fisher (Ruben Bolling), Nicholas Garland, Kevin Kallaugher (Kal), Peter Kuper, Liz Lomax, Stephanie McMillan, Pat Oliphant, Roberto Parada, Chris Payne, Dan Perkins (Tom Tomorrow), Dwayne Powell, Ted Rall, Lynn Randolph, Rob Rogers, Martin Rowson, Gerald Scarfe, Edward Sorel, Ward Sutton, Garry Trudeau, Mark Ulriksen, and Gary Varvel.

We also wish to thank scholars across Duke University who collaborated with us to produce a wealth of programs on related topics such as satire and new media; and balance, bias, and freedom of speech in the contemporary press. We are especially grateful to Jay Hamilton and Ken Rogerson of the Terry Sanford School of Public Policy and James Boyle of the Law School.

Finally, we thank the exhibition's funders. The Duke University Provost's Common Fund and Provost Peter Lange provided major support for the exhibition, the catalogue, and the many educational programs mounted in conjunction with the exhibition. This support made possible the rich interdisciplinary context in which *Lines of Attack: Conflicts in Caricature* is presented. The Sunny Rosenberg Endowment Fund and the Sandra A. Urie and Katherine Urie Thorpe Endowment Fund, which provide support for all Nasher projects involving students in curatorial activities, made possible the students' work on this project and helped to fund this catalogue featuring their research.

Kimerly Rorschach
MARY D.B.T. AND JAMES H. SEMANS DIRECTOR

1. See Katherine de Vos Devine's essay in this catalogue, p. 37, quoting Pat Oliphant in David Wallis (ed.), *Killed Cartoons* (New York: W.W. Norton, 2007), p. 11.

Acknowledgments

THE PROJECT THAT has led to *Lines of Attack* owes a great deal to the exceptional academic environment provided by Duke. The university's commitment to research (notably as an integral part of the undergraduate curriculum), interdisciplinarity, and collaboration with other higher education institutions in the Triangle have all enriched the learning experience essential to the exhibition's inception and realization. First and foremost, the vitality of the show reflects the commitment and intellectual rigor of the students who have worked so hard on it over the last eighteen months: Corina Apostol, Ruthie Chen, Alexis Clark, and Katherine de Vos Devine, all of whom are from Duke, and University of North Carolina-Chapel Hill students Kate Arpen, Alison Hafera Cox, and Mara West. It has been a privilege to work with such able collaborators.

Preparations for the exhibition have profited greatly from the aid and expertise of colleagues across the university, in fields as diverse as political science, law, business studies, and new media. Amongst those who have offered support, I would like to thank Casey Alt, Hans Van Miegroet, Deborah DeMott, Richard Powell, Tom Rankin, and, above all, Jay Hamilton of the Sanford School of Public Policy. It is a particular pleasure to recognize the generous financial aid provided for the exhibition and its educational program by the Provost's Common Fund, which has proved vital for the realization of the organizers' initial ambitions.

Staff in the Department of Art, Art History & Visual Studies, and in particular Bill Broom, Jack Edinger, and John Taormina, have offered crucial help, while colleagues at the Nasher Museum, under the able curatorial guidance of Anne Schroder, have been tireless in transforming our occasionally wayward ideas into practical outcomes. In addition, I would like to thank Chris Lamb, Susan Conway, Abigail Solomon-Godeau, Brendan Nyhan, Tyler Watson, and staff at Brandeis University Libraries and the British Cartoon Archive at the University of Kent in England for help and advice. Thanks are also due to the institutional lenders to the exhibition—the Metropolitan Museum in New York, Mount Holyoke College Art Museum, and the Jane Voorhees Zimmerli Art Museum at Rutgers University. Last, but by no means least, we owe a great debt of gratitude to those caricaturists who took time from their busy schedules to collaborate on this project, and in particular to Kevin Kallaugher (Kal), who has been a particular source of enthusiasm and support.

Neil McWilliam
WALTER H. ANNENBERG PROFESSOR
OF ART & ART HISTORY
Duke University

Mark Ulriksen, *Watch Your Back Mountain,* 2006. Copyright Mark Ulriksen.

ONE HUNDRED AND SEVENTY YEARS separate the revolution that brought Louis-Philippe to the French throne in July 1830 and the Supreme Court decision of December 2000 that confirmed George W. Bush's election as forty-third President of the United States. Equally contested, these events triggered controversy and conflict that reverberated across each man's time in office—culminating in the case of Louis-Philippe in violent overthrow and exile in February 1848. Within the history of art, Louis-Philippe's July Monarchy is celebrated for the extraordinary outpouring of satirical attacks on the king featured in *La Caricature* (1830–1835) and *Le Charivari* (1832–1937), illustrated magazines that effectively inaugurated a tradition of journalistic caricature whose legacy survives as a vibrant source of inspiration down to the present. And yet, in many ways, the opening decade of the twenty-first century seems to presage a period of crisis and renewal for the cartoonist's art, as traditional outlets—most conspicuously the daily newspaper—face an uncertain economic future, and technological change as momentous as anything since the age of Gutenberg radically transforms the media landscape that has sustained journalistic caricature for almost two centuries.

It is this realization that has inspired *Lines of Attack*, an exhibition that brings together two discrete moments in the history of an artistic and satirical genre as a means of inviting the viewer to take stock: to ask how caricature has developed as a journalistic form, to explore its changing visual languages, its cultural references and social appeal, and to consider how effectively it has contributed to political understanding and debate, then and now. In shaping this visual constellation, where consecrated masters such as Daumier, Grandville, and Traviès share gallery space with their present-day American and British counterparts, the show aims to encourage visitors actively to engage with an artistic form that we incline all too often to take for granted—to glance at on the editorial page, perhaps to pause over with a smile, but rarely to question or to analyze in its own right. Yet caricature is arguably a much more potent medium for changing minds—or confirming prejudices—than is usually recognized, not least because of its capacity to convey a topical viewpoint through a judicious blend of humor and an appealing graphic style. This impact has been summed up nicely by the contemporary caricaturist Michael Ramirez: "An editorial cartoon is not just a funny picture. It is a powerful instrument of journalism, sometimes sharp and refined, its message cutting quickly to the point, and other times blunt and overpowering, seizing the reader's attention with its dark imagery."[1]

Rapier or bludgeon, the cartoon, as Ramirez points out, has consequences. Indeed, it was recognition of the cartoonist's devastating ability to satirize and humiliate the king that led the July Monarchy to outlaw political caricature altogether in 1835. The pages of *La Caricature* and *Le Charivari* offer graphic testimony to the power that the authorities wished to suppress. For Daumier and his colleagues, Louis-Philippe's corpulent form and bourgeois bearing were infinitely pliable, allowing the king to be metamorphosed into a fox

Lines of Attack

An Introduction

Neil McWilliam

or a juggler, a barber or a barrel, a pansy or—most famously—a pear.[2] Celebrated artworks, popular fables, classical or religious allusions, subtle visual puns or not-so-subtle scatological imagery all formed part of what E. H. Gombrich memorably described as "the cartoonist's armory."[3]

The visual language embraced with such enthusiasm by these artists had not developed overnight, though the journalistic format in which their work appeared was almost entirely novel.[4] Indeed, by the mid-nineteenth century caricature already had a vigorous history as a visual form, extending back over some hundred and fifty years and boasting practitioners such as the Italian painter Annibale Carracci (the ostensible "inventor" of cartooning in the late sixteenth century), the sculptor Gian Lorenzo Bernini, and Pier Leone Ghezzi, who popularized the genre amongst English aristocrats visiting Rome on the Grand Tour.[5] Yet if Italy can be regarded as the cradle of caricature, the form attained spectacular maturity in Hanoverian England, where satirical engravings, published as independent artworks and sold by a growing network of London-based print sellers, emerged as an increasingly sophisticated and influential channel for political commentary and critique. Particularly following the accession of George III in 1760, caricaturists such as James Gillray, William Dent, and Isaac Cruikshank extended the formal versatility and rhetorical reach of the political cartoon to levels unparalleled elsewhere in Europe.[6] Censorship inhibited the growth of a comparable tradition in Ancien Régime France, and it was only for a relatively brief period during

the Revolution, from 1789 to the summer of 1792, that political caricature was able to flourish freely. Napoleon, too, was wary of the subversive potential of graphic satire and, as with most other forms of commentary on topical events, exerted draconian control over caricature that eased only as his grip on power weakened after 1812.[7] With the establishment of a constitutional monarchy in 1814 under Louis XVIII, cartoonists enjoyed a short-lived moment of free expression during which commentators noted that "caricatures multiply by the hundreds".[8]

If, then as now, caricature necessarily depended on official willingness to respect liberty of expression in order to flourish, the apparent accessibility of the medium, particularly in a society where the majority remained uneducated and disenfranchised, alarmed sectors of the ruling class wary of popular intervention in political life. Condemning caricature's seductively subversive allure, a commentator for the royalist *Conservateur littéraire* sums up fears that have inspired repression over the ages:

> Caricatures . . . address, so to speak, our instinct, while newspapers address themselves only to our intelligence. Any illiterate dawdler can easily grasp the intention of these grotesque scenes and immediately recognizes members of every faction that are depicted. But since he is not always well versed in the knowledge of allegories, he is often exposed to cruel misunderstandings. By being always confronted with men in

priests' cassocks with daggers and torches, he is made to think of all the clergy as murderers and arsonists.[9]

Perhaps unconsciously, the writer's deep mistrust for this newly popular medium expresses itself in the form of a contradiction: the ignorant viewer is said at one and the same time instinctively to grasp the intent of oppositional satire and to cruelly misunderstand the visual language of caricature that works to undermine the credibility of established institutions and their representatives. But, clearly, what is most feared is a true meeting of minds between artist and spectator, with the cartoon's graphic violence forging a hidden bond between the subversive creator and an army of malcontents ready to strike.

Such fears quickly resurfaced in the volatile political climate of the early 1830s. Louis-Philippe had been ushered onto the throne by a cabal of politicians and financiers anxious to forestall a republican takeover following the violent overthrow of the Bourbon monarch Charles X (1824–30). The uprising that shook Paris in July 1830 had been triggered by Charles's provocative attempt to annul the results of a recent election, but more fundamentally Louis-Philippe was expected to reverse his predecessor's efforts to reassert the absolutist authority of the crown as it had existed before 1789. The new king had promised to respect, and strengthen, the constitutional charter that Charles had comprehensively undermined and to govern as a consensual "King of the French," reaching out to political factions on left and right. Initial expectations that Louis-Philippe would promote an ideological *juste-milieu* (happy medium) were soon disappointed, however. Growing social inequality, which the new monarch had promised to address, was allowed to fester as the regime adopted a laissez-faire commitment to industrial growth and allied itself with the Catholic church, widely disliked following the July Revolution for its support for Charles X. Such a climate bred growing dissent in oppositional circles, echoed in the newspaper press and, with increasing virulence and potency, in political caricature. As popular discontent mounted, the authorities found themselves confronted by uprisings in Paris and Lyon, as well as a series of assassination attempts culminating in an attack in July 1835 by Giuseppe Fieschi that killed eighteen bystanders while sparing the king himself.[10]

Official sensitivity towards cartoonists' capacity to incite dissent and foster insurrectionary sentiment had emerged as *La Caricature*, which Charles Philipon established in November 1830, spearheaded satirical resistance to the new regime. Despite assurances that the new regime would uphold free expression, as enshrined in the constitutional charter, Justice Minister Jean-Charles Persil did not hesitate to argue that visual, as opposed to written, forms of dissent constituted acts rather than speech and were thus not protected.[11] It was not long before Philipon and his artists faced fines and imprisonment for caricatures that allegedly fomented disrespect for the person of the king, and political caricature itself was effectively stifled in the broader onslaught against the press in

September 1835 that followed Fieschi's assassination attempt.

What is most striking today as we look back through the pages of *La Caricature* and *Le Charivari* is the relentlessness of their attacks on Louis-Philippe. Though prominent ministers and members of the royal entourage play a supporting role, the king himself is transformed into a figure of suspicion and contempt through an unremitting campaign that stripped the leading representative of the political elite of his symbolic aura and reduced him to—at best—human proportions. The language of caricature effectively corrodes respect by debasing its consecrated object, deforming his features and physique, likening him to figures or objects of lowly status, or pointing up his shortcomings by portraying him in the guise of real or fictional personalities who are generally admired.[12]

Such a strategy, which first emerged in eighteenth-century England, grows out of a personalization of politics that has become all the more pervasive as an era of mass media has, at least notionally, transformed remote leaders into knowable, rounded personalities[13]. Caricatures of the Bush administration take for granted certain "givens" about the president himself. For sympathizers, he was down-to-earth and unpretentious, a man's man, who marked a break with the reputed dissipation of the Clinton presidency and was capable of facing down effete opponents such as Al Gore or John Kerry; less charitably (and with increasing vehemence), Bush was regarded by many others as intellectually inadequate, incoherent, and shiftless. Positive representations—Bush as cowboy or plain-spoken Texan—came to be used against him, while critics developed a broad repertoire of negative personifications—Bush as infant, midget, monkey, or tin-pot dictator—as the post-9/11 consensus fragmented with the invasion of Iraq, Hurricane Katrina, Abu Ghraib, wiretapping revelations, and the financial collapse.[14]

Cartoonists were not, of course, alone in crafting competing images of the Bush presidency. While caricature played its part in solidifying perceptions of the nation's leader, its effectiveness relies on a complex interplay within a range of different arenas, from the editorial page and talk radio to nightly news and, increasingly, the internet. In order to elicit the viewer's assent—whether in favor of the president or against him—cartoonists must work within boundaries defined by the aggregate of these representations and at the same time try to reposition these boundaries through the rhetorical tools at their command. For the ethos of political caricature, in contrast—at least theoretically—to that of reportage or editorial commentary, is not one of fairness or balance, but rather about making a point, decisively, economically and, more often than not, with extreme prejudice. As a satirical form, caricature is best suited to the attack mode, and in this regard, though for different reasons, neither George Bush's predecessor, Bill Clinton, widely portrayed by caricaturists as the priapic president, nor his successor, Barack Obama, have escaped cartoonists' critical attentions.

If the cartoonist today is deeply implicated in a cacophonous array of competing representations, for Daumier and his contemporaries visual satire stood out in gaudy contrast to a much more uniform and monochromatic media landscape. Philipon's publications, with their eye-catching use of lithography and, more sporadically, wood engraving, injected humor and visual appeal into a world dominated by daily papers that were entirely unillustrated and invariably led with verbatim reports of parliamentary debates and court proceedings. Newspapers flourished under the July Monarchy as never before (some thirty dailies were published in Paris throughout the period), though they attracted a relatively restricted readership on the basis of political affinity rather than editorial allure.[15] Yet, as the success of Philipon's enterprise attests, things were rapidly changing. Indeed, in many ways the 1830s match the present day as a period of revolutionary innovation in the media. Encouraged by a gradual rise in literacy and improved distribution networks, new journals and magazines were established in unprecedented numbers and appealed to a broadening social constituency. As advertizing was introduced to hold down subscription rates, so newspaper owners attempted to attract new readers with a more varied fare of cultural reportage and serialized novels. Arguably, the 1830s saw the emergence of a modern media economy in which printed matter was fully integrated into a burgeoning consumer society.[16]

Technological change was a vital ingredient in this transformation and was particularly important for *La Caricature* and *Le Charivari*. Both journals depended on a new reproductive technique—lithography, invented by Alois Senefelder in 1796—which allowed cheap and practically unlimited production of graphic images. In contrast to the intaglio processes that had dominated single-sheet print satire, and which limited output as the incised lines on the copper plate used for printing wore away through use, the lithographic stone, on which artists drew their image directly, survived repeated impressions. Though lithography proved cumbersome as a graphic accompaniment to letterpress (a four-page journal like *La Caricature* had to be printed twice to accommodate each separate process), both it and wood engraving opened up new horizons to publishers anxious to explore the growing market for popular periodicals.

Publishing today stands at a similar crossroads, the consequences of which will necessarily be critical for the evolution of caricature as a journalistic medium. As digital media inexorably reshape news distribution, so the cartoonist's traditional niche on the editorial page or the magazine cover is under threat. Media consolidation and declining sales have severely undercut the profession in the United States. Local dailies, anxious to cut production costs and reluctant to offend the political sensibilities of readers or advertisers by running possibly contentious images, increasingly regard caricature as an unnecessary luxury or a potential liability.[17] Yet, as broadsheet gives way to broadband, many caricaturists have come to regard new media less as a threat than as a tool that offers

innovative ways to produce and distribute their work. As the present exhibition demonstrates, the cartoon no longer has to exist as a physical object but can be generated exclusively on the computer screen and preserved in digital form. Beyond this, online journals offer caricaturists a new platform for animated formats, a direction followed by numerous internet sites that offer an outlet for satirical sketches and parodies oblivious to, if not actively contemptuous of, editorial deference to balance and good taste.

Far from fading away as an archaic medium, caricature today is experiencing a period of vigorous, if traumatic, renewal. *Lines of Attack* offers testimony to this, with an array of work that exploits both traditional and new media in exciting and imaginative ways, and demonstrates caricature's continuing presence not only on the editorial page of established dailies, but as an integral ingredient in magazine publishing, comics, and the alternative press. In recent years, the spotlight has been turned on caricature in sometimes unexpected, occasionally unfortunate, ways: controversy surrounding the publication of cartoons portraying Muhammad by the Danish daily *Jyllands-Posten* in September 2005, for example, compounded international tensions and provoked riots that led to scores of deaths. More limited controversies, particularly surrounding portrayals of Barack Obama both before and after his election as president, have similarly attracted media attention, generating debate over stereotyping and racism in graphic satire. Such high-profile debates, together with the frequency with which artists and editors have to deal with irate readers angered by supposedly partisan or disrespectful cartoons, vividly demonstrate that the medium still has the capacity to provoke a strong response and, on occasion, possibly even to dislodge prejudice and the stultifying grasp of received ideas.

From Louis-Philippe to George W. Bush, caricature has come a long way, though artists at work today still inhabit a visual landscape recognizably shaped by predecessors such as Daumier and his contemporaries. While in the 1830s both the authorities and their critics understood that the stakes were high enough to entail crippling fines, imprisonment, and the eventual prohibition of political cartooning, in today's more liberal environment the freedom to mock those in power—to challenge their specific policies or broader authority—seems assured, in legislative if not necessarily in institutional terms. And yet the question remains: does caricature carry the same punch today as it did 180 years ago? Can it still aggravate the powerful and encourage citizens to look beyond the headlines and the spin? *Lines of Attack* offers some lines of enquiry, encouraging viewers to look afresh at this venerable art form as it embraces the digital age.

NOTES

1. Michael Ramirez, *Everyone Has the Right to My Opinion* (Hoboken, NJ: Wiley, 2008), inside cover.

2. Amongst the most useful guides to caricature during the period, see David S. Kerr, *Caricature and French Political Culture 1830–1848: Charles Philipon and the Illustrated Press* (Oxford: Oxford University Press, 2000).

3. E. H. Gombrich, *The Cartoonist's Armory* (Durham, NC: Duke University Press, 1963), first read at Duke University in March 1962 as the Benjamin N. Duke Lecture in the History of Art. On parody as an essential part of this armory, see the essay by Katherine Arpen in this catalogue.

4. In France, the years following the defeat of Napoleon and the return of the Bourbon monarchy in 1814 had seen the publication of a handful of short-lived magazines, such as *Le Nain jaune* (December 1814–July 1815) and *L'Homme gris* (1817–1818), that offered cartoons, generally as an occasional supplement. In 1830, Charles Philipon, future editor of *La Caricature* and *Le Charivari*, published the comic journal *La Silhouette* (December 1829–January 1831), featuring lithographic caricatures. It is his later, more celebrated publications, featured in the current exhibition, that are generally recognized as heralding a new era in comic journalism.

5. For a general survey of caricature, see, for example, Edward Lucie-Smith, *The Art of Caricature* (Ithaca: Cornell University Press, 1981).

6. For a useful overview of English caricature of the eighteenth century, see Diana Donald, *The Age of Caricature: Satirical Prints in the Reign of George III* (New Haven: Yale University Press, 1996).

7. On the Revolutionary period, see Grunewald Center for the Graphic Arts, *French Caricature and the French Revolution 1789–1799* (Los Angeles, 1988); on Napoleon, see Catherine Clerc, *La Caricature contre Napoléon* (Paris: Editions Promodis, 1985).

8. From *Le Nain jaune* 25 May 1815, p. 239, quoted in Nina Maria Athanassoglou-Kallmyer, *Eugène Delacroix: Prints, Politics and Satire 1814–1822* (New Haven: Yale University Press, 1991), p. 1.

9. A. M. "Beaux-Arts. Sur les lithographies nouvelles," *Le Conservateur littéraire*, June 1820, p. 207. Cited in ibid., p. 9 (translation slightly modified).

10. The best English-language survey of the period remains J. A. C. Collingham, *The July Monarchy: A Political History of France* (London: Longman, 1988).

11. "[W]hen opinions are converted into acts by the presentation of a play or the exhibit of a drawing, one addresses people gathered together, one speaks to their eyes. That is more than the expression of an opinion, that is a deed, an action, a behavior, with which article seven of the Charter is not concerned." Cited in Robert Goldstein, *Censorship of Political Caricature in Nineteenth-Century France* (Kent, OH: Kent State University Press, 1989), p. 2. On the issue of censorship, see the catalogue essay by Katherine de Vos Devine.

12. The grotesque as a caricatural form is discussed in this catalogue by Alison Hafera Cox.

13. Strategies in contemporary American caricature are examined in Chris Lamb, *Drawn to Extremes: The Use and Abuse of Editorial Cartoons* (New York: Columbia University Press, 2003).

14. On monkey imagery, see the article by Alexis Clark in this catalogue.

15. On the history of the press, see Irene Collins, *The Government and the Newspaper Press in France, 1814–1881* (Oxford: Oxford University Press, 1959), and the essays in Dean de la Motte and Jeannene M. Przyblyski (eds.), *Making the News: Modernity and the Mass Press in France* (Amherst: University of Massachusetts Press, 1999).

16. See Beatrice Farwell (ed.), *The Cult of Images: Baudelaire and the 19th-century Media Explosion* (University of California at Santa Barbara Art Museum, 1977).

17 See, for example, David Wallis (ed.), *Killed Cartoons: Casualties from the War on Free Expression* (New York: W. W. Norton and Co., 2007). Ongoing difficulties faced by cartoonists are discussed on professional websites such as *The Daily Cartoonist* (http://dailycartoonist.com/index.php/category/editorial-cartooning/) and the site of the Association of American Editorial Cartoonists (http://editorialcartoonists.com/).

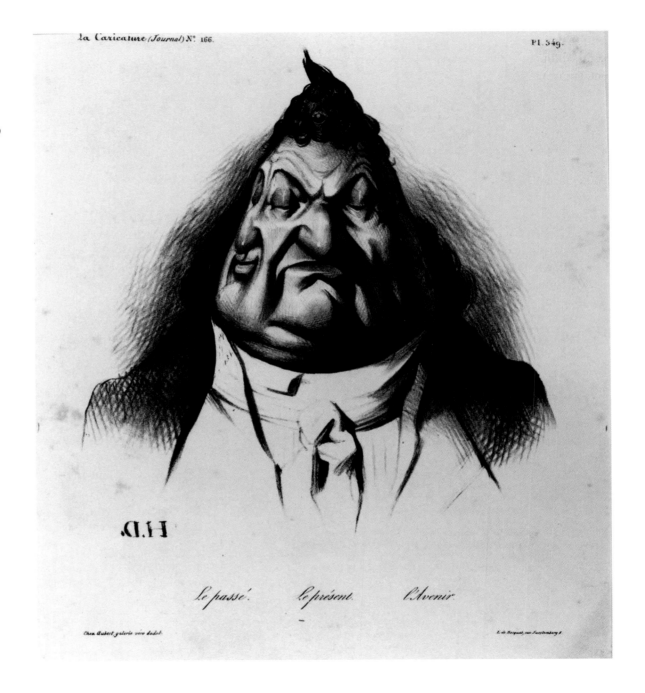

Honoré-Victorin Daumier, *Le Passé. Le Présent. L'Avenir.* (Past. Present. Future.), *La Caricature*, 9 January 1834. The Metropolitan Museum of Art/Art Resource, New York.

IN HONORÉ DAUMIER'S 1834 LITHOGRAPH of King Louis-Philippe, *Le Passé. Le Présent. L'Avenir.* (Past. Present. Future) the Citizen King's head is transformed into a monstrous apparition. Rather than one face presented as a likeness, three faces share overlapping eyes, jowls, folds of skin, and a central toupee as they morph and twist into a single bizarre form. In the print, first published in Charles Philipon's journal *La Caricature*, Daumier exaggerates the heavy roundedness of Louis-Philippe's chin and jaw and his narrow pointed forehead, creating a head that has the overall shape of a pear. Philipon was the first caricaturist to compare the general form of the king's head to the bottom-heavy fruit, and the humorous association quickly caught on.[1] During the 1830s, largely due to the popularity of journals like *La Caricature*, the fruit became an emblem for Louis-Philippe, and viewers became accustomed to seeing the king as a pear and pears as a king. By embedding the general shape of a pear within the three faces of Louis-Philippe, Daumier presents a head that is in process, neither a piece of fruit nor a human head but something in between. Similarly, in his caricature of George W. Bush in *Bush Throat Job* (page 68), published in the *Guardian* in 2003, Steve Bell pulls the former president's face into an elongated snout, creating a creature that seems neither purely human nor animal but perhaps a combination of the two. The "in between-ness" of these figures, their recognizability as hybrid creatures, has its origin in the visual grotesque, a medium that like caricature delights in exaggeration and distortion.

The meanings and characteristics of the grotesque, both in word and image, are complex and various. As defined by an exhibition on the topic, *Repulsion: Aesthetics of the Grotesque*, the grotesque image is "particularly hideous, frightful, revolting, monstrous or bone chilling in its atavistic ability to evoke feelings of naked terror or repugnance in us."[2] When the word first appeared in the mid-sixteenth century, however, its connotations were quite different. The whimsical figures in frescos discovered on the walls of underground rooms—or grottos—in Roman villas were coined *grottescas*, the word denoting the fantastical rather than the horrific.[3] These frescoes were characterized by their representation of human heads, animals, and plant life alongside images of mythological creatures like nymphs, satyrs, and centaurs.[4] Often half human and half plant or animal, these early painted figures embody major visual and thematic elements of the grotesque: transformation, metamorphosis, and the crossing of boundaries through the pictured human body. Both grotesque imagery and political caricature represent boundaries and moments of metamorphosis when people or objects "suddenly twist themselves into other shapes" and therefore stand "on the threshold of two meanings."[5] While the grotesque pictures human beings becoming horses or trees, caricature imagines a foolish man as a donkey, or, in the case of Louis-Philippe, transforms a king into a pear.

The frequent and deliberate application of formal exaggeration in grotesque imagery links it to the visual language of caricature, a comparison that has been drawn since the eighteenth century by scholars and critics.[6] Both caricature and the grotesque rely on invention, a predilection for metamorphosis, and irreverence for the boundaries that separate human figures from

Drawing Boundaries

Comic Critique in the Grotesque Bodies of Louis-Philippe and George W. Bush

Alison Hafera Cox

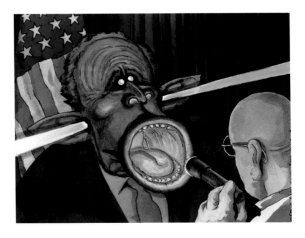

animal or inanimate forms. Like the grotesque, caricature makes use of the human body to create types that represent an attitude, a situation, or a social category. It transforms familiar people, places, and things into new and sometimes repulsive forms through the inventive use of distortion. By treating actual individuals in a reductive manner, caricature turns identifiable people into types, allegories, or personifications. But while the two forms share many commonalities, caricature employs formal elements of the grotesque to offer a more overtly political, and clearly biting, commentary on people and their ideas and actions. Cartoonists today, like their counterparts in 1830s France, hone their satirical skills on the nonsense and humor found in the political world, making familiar public figures appear bizarre and even terrifying.

The caricatural grotesque, as this exhibition shows, quite frequently centers on the political body. One reason cartoonists employ the grotesque to reshape and form political bodies is because it has the power to be both politically subversive and comically pleasurable, an ability first noted by Russian literary critic Mikhail Bakhtin in *Rabelais and His World* (1965), a study on the meanings of the grotesque in the novels of Rabelais.[7] Primarily interested in how human beings think and behave, Bakhtin considers the ways that language is used and how its application shapes the beliefs of a given society. He argues that Rabelais exploits the grotesque as a manifestation of political conflict through the representation of human physiology. For Bakhtin, grotesque figures are ambivalent creatures, transgressing boundaries and drawing multiple, disparate elements together to create something new and unexpected. They may take the form of combinatory bodies composed of animals, objects, and plants, or they may appear as horribly distorted human figures. Because of their malleability and temporality, grotesques can have both positive and negative associations, embodying renewal and rebirth as well as signaling death and destruction.

Looking again at Bell's rendition of the president's face in *Bush Throat Job*, it becomes clear that while the caricature is based on Bush's physiognomy, Bell has exaggerated and distorted his appearance to evoke a sense of the fantastical or monstrous: the eyes are pushed together and reduced in size; the ears are sloped and positioned low on the head, tapering into a rounded point; the nose is elongated, thinned and directed towards the oversized and trumpet-like mouth. For Bakhtin, the mouth and nose are the most important of all human features in representations of the grotesque. A trademark element of the grotesque figure is the gaping mouth exaggerated in size and shape until it dominates all other traits and becomes a wide-open abyss.[8] Bell's characterization of Bush's mouth as open, nearly perfectly

round, and cavernous seems particularly subhuman. Small, widely spaced teeth frame a fleshy pink tongue, above which hangs a knotted noose in place of tonsils. A physician shines a flashlight into Bush's widely parted lips, examining the back of his throat. The light passes through the president's head uninhibited, illuminating his beady eyes and distended nostrils while beams of light break from his ears. The glow of Bush's eyes does more than support the implied emptiness of his head; it also makes him seem alien, mechanized, and lifeless. The presence of the hanging noose, moreover, suggests that this is a dangerous body capable of doing deadly harm. Bell uses the external surface of Bush's body to comment on the internal character of the president.

Even as Bell's caricature distorts the president's features to make a political point, it relies on the viewer's ability to identify the subject along with the moment being parodied. The cartoon alludes to a video of former Iraqi leader Saddam Hussein being examined by a United States military doctor shortly after his capture in December 2003. At one point in the footage, Hussein is shown with his mouth open as the physician takes a DNA sample from the inside of his cheek.[9] Formally, though, through the exaggeration and distortion of Bush's face, particularly his mouth, Bell creates a new figure, one that is both familiar and strange. According to Bakhtin, this kind of instability and tension between the familiar and the fantastic epitomizes the creative possibilities of the grotesque body specifically because it is always "in the act of becoming . . . never finished, never completed; it is continually built, created and builds and creates another body."[10] Because grotesque bodies are often in process, with multiple

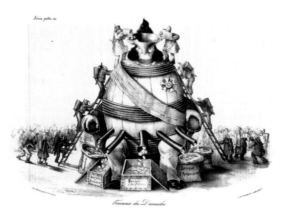

forms inhabiting a single image, these figures can be read as common or strange, ridiculous or terrifying, or both at once.

One important characteristic of the grotesque body is that it does not completely morph into abstracted figures, but remains at its core human.[11] Because grotesque figures are often open, protruding, and unfinished, they continually exhibit a fascination with the material life of the body and its processes, particularly of the "lower stratum."[12] According to Bakhtin, degradation and debasement are essential elements of the grotesque, as becomes most apparent in "images of bodily life such as eating, drinking, copulation, . . . [and] defecation."[13] This type of grotesque figure appears regularly in caricatures of political figures, where consumption and waste take on metaphoric meanings associated with power, governance, and greed. Take, for instance, Auguste Desperret's lithograph of King Louis-Philippe *Tonneau des Danaïdes* (*The Danaides' Barrel*) from 1833 (page 50). The king is pictured seated on a *chaise percée*, a chair with an opening in the seat that was used as a commode.[14] Near his head and at the top

of two steep ladders, lower- and middle-class citizens of Paris empty coins into a funnel inserted in the king's mouth. The coins pour out through tubes into bags and boxes labeled with the names of the foreign banks in which Louis-Philippe was accused of keeping his money.[15] By the time this image appeared in Le Charivari, the rendering of an overweight king with a small pear-shaped head was familiar to its readers. Published in the same journal two years earlier, Honoré Daumier's well-known caricature Gargantua (page 34) shows the pear king in a similar guise as the devouring giant of French folklore made famous by Rabelais' epic tale of gluttony and material greed.[16]

In Desperret's print, the king is transformed into a mechanized beast of consumption and avidity. Towering over the masses, Louis-Philippe's torso becomes a wide barrel. His arms and legs brace the colossal form as his head is perpetually flung back in a passive pose of ingestion. Taken from Greek mythology, the title of the lithograph refers to the story of King Danaides of Argos and his fifty daughters. At their father's request the daughters murder their bridegrooms on their wedding night. Condemned to Hades, they are eternally forced to pour water into a jar with holes in the bottom.[17] Like King Danaides' daughters, the lower and middle classes of France pictured in Desperret's print are forever condemned to feed an insatiable creature, half man and half machine. The massive girth of the king's barrel torso demonstrates the endlessness of this task, as does the rapidity of his bodily process of consumption, digestion, and expulsion, made transparent before a physically and politically diminutive public.

By revealing parts and processes of the body that are usually private, the caricatural grotesque has the power to be socially and politically subversive. Its emphasis on orifices and deformities exposes bodily elements and actions that are normally suppressed by social codes of behavior. According to Bakhtin, all grotesque bodies tend to be coarse and comic, but when they challenge social hierarchies and conventions, they become carnivalesque, a term referring to pre-Lenten periods of celebration in predominantly Christian communities that traditionally involved actions and images that represented "the world turned upside-down." These masquerades and episodes of feasting signified choreographed departures from the dominant hierarchies and constraints of everyday life. The subversive and anti-authoritarian aspects of carnival are emphasized through the regular mocking of authority figures, particularly political and religious leaders. For Bakhtin the carnivalesque represents the voice of the people. To ridicule the king and national leaders through the debasement of their physical bodies was not only to mock but also to ignite what Bakhtin saw as the people's power to regenerate the entire social system. The carnivalesque grotesque body is fundamentally about rejecting and renewing entrenched social codes and cultural values.

Carnivalesque grotesques can also take the form of more monstrous figures, whose bodies are represented as tormented or decomposing. These figures do not take satirical advantage of the body's human processes, but rather of its vulnerabilities, pointing to its inevitable collapse and decomposition. An example of this type of hideous grotesque can be seen in British cartoonist Gerald Scarfe's depiction of George W. Bush in

caricatures such as *My Election Chances* from 2004 (page 71). In general, Scarfe's depictions of George Bush are gruesome and, like all of his caricatures, display his own brand of intense dark humor.[18] Throughout his work portraying the American leader, Scarfe heavily exaggerates the president's physiognomy, pulling Bush's eyes to the center of his head and emphasizing the slack looseness of his chin and mouth. It is in Scarfe's exaggeration of Bush's ears and bodily form, however, that the caricature moves beyond humorous physiological coincidence and transforms Bush into a fearful and repulsive creature.

In *My Election Chances* the president is shown hunched and bony, standing on a pile of human corpses. His oversized head is dominated by a long, loose mouth and chin, with bat-like arched and pointed ears. Playing on a familiar image of Bush as cowboy, Scarfe shows the president's legs bowed and cowboy-booted, spurs and all. Like Bell, Scarfe often draws on images of the president taken from the mass media as inspiration for his own visual characterizations. *My Election Chances* makes direct reference to imagery taken from the Abu Ghraib prison scandal. Beginning in April 2004, newspaper accounts and photographs of the physical, psychological, and sexual abuse of detainees came to public attention. These graphic images soon became incorporated in satirical critique of the administration's handling of the war in Iraq.[19] The first half of the caption floating over Bush's head—"This is terrible! Appalling! Horrific!"—is charged with multiple meanings and points of reference, at once invoking the prison scandal itself, the war in Iraq via the broken and wounded bodies of soldiers beneath

Bush, and even the strained figure of the president himself. The image is indeed horrific and appalling, as is the line that follows: "Just imagine what it's doing to my election chances." Scarfe's transformation of Bush is unrelenting and biting, both satirical and grotesque.

Scarfe's frequent use of hideous grotesques in his satires of political figures points to a broader trend within contemporary caricature. While the grotesque body in caricature today is not altogether rare in the United States, British artists in particular are more apt to include formal elements of the grotesque in their portrayal of actual political persons. When contemporary British cartoonists like Gerald Scarfe, Steve Bell, and Martin Rowson create hybrid creatures and fantastical, monstrous figures they not only recall French caricatural style of the mid-nineteenth century, but also draw on a long tradition of the grotesque in British satirical prints, as evidenced by the work of eighteenth-century artists like James Gillray and Thomas Rowlandson.[20] The very nature of the grotesque, its ability to shock and even repulse, makes it an unruly element within the mass media. As seen in Scarfe's rendition of Bush, the grotesque can be used to deliver a harsh and cutting critique, one that may seem unforgiving and even violent.

Even though the grotesque can offer harsh reproach through repulsion and shock, it is always grounded in the comic possibilities of metamorphosis and the incongruous combinations of unlikely parts. On a most basic level, caricature and the grotesque share the dual aims of humor and satire, achieving political censure primarily through the evocation of laughter. In

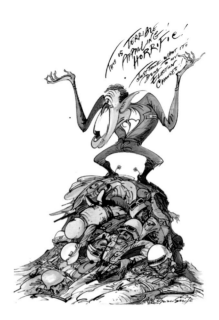

Gerald Scarfe, *My Election Chances*, 2004. Copyright Gerald Scarfe.

representing figures that can be characterized as distorted, bizarre, and hideous, and in joining disparate human and animal or plant elements in strange, dissonant amalgamations, the caricatures of Louis-Philippe and George W. Bush discussed here follow the conventions of the grotesque and mold them to their own political purposes. The application and reconceptualization of the visual grotesque in today's brand of satire demonstrate that there remain significant formal and contextual links between contemporary cartoonists and artists working at the outset of modern journalistic caricature in 1830s France.

NOTES

1. During his trial on 14 November 1831, as part of his defense against charges of violating the dignity of the king, Philipon drew four sketches of the king's head systematically transforming into a pear. His drawing was later published as a lithograph in *La Caricature*. See David S. Kerr, *Caricature and French Political Culture, 1830–1848: Charles Philipon and the Illustrated Press* (Oxford: New York, 2000).

2. *Repulsion: Aesthetics of the Grotesque*, exhibition catalogue with essays by Allan L. Ludwig and Joel-Peter Witkin (New York: Alternative Museum, 1987), p. 4.

3. David Summers, "The Archaeology of the Modern Grotesque," in *Modern Art and the Grotesque*, ed. Frances S. Connelly (Cambridge and New York: Cambridge University Press, 2003), pp. 20–46.

4. For more on the origins and history of the grotesque, see Wolfgang Kayser, *The Grotesque in Art and Literature*, trans. Ulrich Weisstein (1957; reprint, New York: Columbia University Press, 1981); Frances Barasch, *The Grotesque: A Study in Meanings* (The Hague and Paris: Mouton, 1971); and André Chastel, *La grotesque* (Paris: Le Promeneur, 1988).

5. Werner Hofmann, *Caricature from Leonardo to Picasso* (New York: Crown, 1957), p. 28.

6. German critic Friedrich Schlegel described caricature as "a passive connection of the naïve and the grotesque." As quoted in Virginia A. Swain, *Grotesque Figures: Baudelaire, Rousseau, and the Aesthetics of Modernity* (Baltimore: The Johns Hopkins University Press, 2004), p. 76. In *The Grotesque in Art and Literature*, Wolfgang Kayser writes that "the grotesque is caricature without naïveté," p. 53. For more on the early history of the grotesque and caricature, see Justus Möser, *Harlequin, or the Defense of the Grotesque-Comic* (London: printed and sold by W. Nicoll and R. Main, 1766); Karl Friedrich Flögel, *History of the Groteque-Comic* (1788); Charles Baudelaire, "Of the Essence of Laughter, and generally of the Comic in the Plastic Arts," in *Selected Writings on Art and Literature* (London: Penguin, 1992 [1855]), pp. 140–61; and Friedrich Theodor Vischer, *Uber das Erhabene und Komische* (Frankfurt am Main: Suhrkamp, 1967 [1847]).

7. Mikhail Bakhtin, *Rabelais and His World*, trans. Helene Iswolsky (1965; reprint, Cambridge: MIT Press, 1968).

8. Ibid., p. 317.

9. "Coalition Forces Acted on Intelligence to Launch Raid," *PBS Online News Hour*, http://www.pbs.org/newshour, 14 December 2003, 10:04am EST.

10. Bakhtin, *Rabelais and His World*, p. 317.

11. Frances S. Connelly, "Introduction," *Modern Art and the Grotesque*, pp. 1–19.

12. Bakhtin, *Rabelais and his World*, p. 309.

13. Ibid., p. 317.

14. Elise K. Kenney and John M. Merriman, *The Pear: French Graphic Arts in the Golden Age of Caricature* (South Hadley, MA: Mount Holyoke College Art Museum, 1991), pp. 84–85.

15. Ibid., p. 85.

16. See Elizabeth C. Childs, "Big Trouble: Daumier, Gargantua, and the Censorship of Political Caricature," *Art Journal* 51 (Spring 1992), pp. 26–37.

17. M. C. Howatson and Paul Harvey, *The Oxford Companion to Classical Literature* (New York: Oxford University Press, 2005), p. 168.

18. Gerald Scarfe, *Drawing Blood: Forty-Five Years of Scarfe Uncensored* (London: Time Warner Books, 2005).

19. Seymour M. Hersh, "Torture at Abu Ghraib," *New Yorker*, 10 May 2004.

20. See Diana Donald, *The Age of Caricature: Satirical Prints in the Reign of George III* (New Haven: Yale University Press, 1996).

ON 24 MARCH 2004, the *Guardian* newspaper published British cartoonist Steve Bell's *Al Who'Da??* (page 16), a satirical look at the moment Chief of Staff Andrew Card stepped in on live television to inform the president that a second plane had hit the Twin Towers at the World Trade Center in New York. That single televised moment, captured in a number of news photographs, had quickly become familiar to the world in the days following the September 11 attacks and, as Bell's cartoon suggests, remained so some years later.[1] Bell's cartoon offers a useful entry into many of the issues to be addressed in this essay, among them the potential for parodic satire to engage the viewer on multiple levels of meaning, the necessity of recognizable source material, and the resulting expansion of sources employed in parodic satires from the reign of Louis-Philippe to the present day.[2] Unlike the parodic satires produced for *La Caricature*, traditionally based on classical and academic works of art, Bell's cartoon draws from an entirely different area of culture: the popular news photograph. Selecting a source image that was immediately recognizable to those who followed the events two and a half years earlier, Bell's cartoon invites the viewer to return with new eyes to the original photograph and the range of responses it evoked.

The news image of Bush and Card had initially represented a moment when much of the world rallied behind the president, sympathetic to the weight involuntarily thrust upon his shoulders. With distance and new information, many began to question how much of that day and the resulting wars was unavoidable. The publication of Bell's cartoon coincided with the release of former counterterrorism advisor Richard Clark's book *Against All Enemies*, in which he alleged that prior to September 2001 the Bush administration had ignored warnings regarding Osama bin Laden and an al Qaeda-coordinated attack on the United States. In light of Clark's allegation of negligence, Bell's cartoon reworks the scene and solicits a different set of responses than the original image. Playing off the protruding mouth and quizzical eyebrows commonly seen in his caricatures of Bush, Bell depicts the president caught off guard, able to respond only with confusion. While Bush's approval ratings in the United States had soared to 90 percent in the weeks following the attacks, the administration's shift of focus from Afghanistan to Iraq had since resulted in a decline in public support. By the time Bell's cartoon appeared in the *Guardian*, the president's approval rating had nearly returned to pre-9/11 levels. Bell's cartoon came at a propitious time, revisiting a familiar image within a new context as the public reevaluated their opinions of Bush's role in protecting the nation. The familiarity of the original image and the satirical reworking of the scene, coupled with Bell's physical caricaturing of the president's features, are what give the cartoon its critical punch.

As parodic satire, Bell's cartoon is part of a long tradition within political caricature that can be seen in the material presented in this exhibition. From the earliest issues of *La Caricature*, nineteenth-century caricaturists turned to popular visual and literary texts as sources in their critiques of Louis-Philippe. Whether he was depicted as Judas betraying Liberty at the Last Supper, a bloated Farnese Hercules, or La Fontaine's cat devouring his

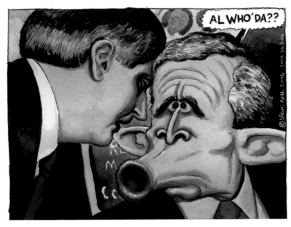

strengths,"[5] parodic satire within the caricatural tradition faults, weakens, and diminishes the *subject*, not the source, of the parody.[6] It is not mere stylistic imitation or mockery of the source; it must go beyond the source, beyond the parody itself, to offer weightier critiques. As literary theorist Linda Hutcheon suggests, parody's "appropriating of the past, of history, its questioning of the contemporary by 'referencing' it to a different set of codes, is a way of establishing continuity that may, in itself, have ideological implications."[7] The satirized subject no longer exists only in this moment or within the realm of politics alone. Drawing on the original source, the caricaturist places the object of his attack within a much larger political, historical, and cultural orbit.

In their appropriation of the past, parodic satires carry with them a built-in meaning, modified and interpreted anew by the caricaturist and viewer. The critique arises from the incongruities created by the caricaturist's transformation of the original work's artistic style and subject matter. The first transformation—the distortion of the original work's artistic style—often takes the form of caricature, exaggerating the features of the satirized figure to criticize his or her character.[8] When it comes to subject matter, the original source provides the initial context for interpretation—the model for how the viewer "expects" subjects to act within the given scene—and it is by denying these expectations through a substitution of characters that the parodic satire gains its charge and presents its critical judgment to the viewer.

In many cases, the caricaturist places the object

subjects, the Citizen King of France was transformed into some of the most familiar images of European culture.[3] As evidenced by Bell's *Al Who'Da??* many contemporary cartoonists likewise draw inspiration from the range of images that their cultures offer them, but they cast a much wider net. No longer wedded solely to classical texts or the masterpieces of Western art, contemporary parodic satires also draw source images from television shows, films, and the news media. While the source material has expanded over the years, the parodic tradition remains strong, suggesting its effectiveness as an entertaining and critically successful form of satire.

Dating back to the literature of ancient Greece, parody can take a wide range of forms, at times unaccompanied by any critical intent and in other cases taking aim at the original text, be it literary, visual, musical, or theatrical.[4] Rather than "[wounding] the originals (however slightly), pointing out faults, revealing hidden affectations, emphasizing weaknesses and diminishing

of attack in the role of an unsympathetic or unfavorable character present in the original text. This form is commonly seen in the parodic satires of *La Caricature*, in which Louis-Philippe is often cast as the villain to French Liberty's victim: Judas and Jesus in Auguste Bouquet's parody of Leonardo's *Last Supper;*[9] executioner and Lady Jane Grey in Bouquet's *Exécution de Désirée Françoise Liberté* (page 56), a parody of Paul Delaroche's *The Execution of Lady Jane Grey*; Aegisthus and Agamemnon, in A. Casati's reworking of Pierre-Narcisse Guérin's 1817 canvas in his *Parodie du tableau de la Clytemnestre* (page vi). In such cases, an incongruity arises when the viewer recognizes that the main subjects of the parodies are not behaving in a manner appropriate to their position. We are therefore surprised when we see an image of the king of France wielding an executioner's axe or the president of the United States sitting at a table of mobsters (Steve Brodner, *The Bushanos*, page 79).

In other cases, the caricaturist adopts an original source that is, in itself, critically neutral, with the characteristics of the original subject only becoming condemnatory when associated with the parody's target(s). While the main characters of the often-parodied *Wizard of Oz* are, by their own admission, lacking desirable qualities, their shortcomings are offset by the group's quest for self-improvement. In *Yellow Cake Road* (page 18), Steve Bell's parodic satire of the 1939 motion picture, however, Dorothy's naïveté, the Scarecrow's empty head, the Tin Man's missing heart, and the Lion's lack of courage become critical faults when applied to the characters of George Bush, Dick Cheney, Donald Rumsfeld, and Tony Blair.

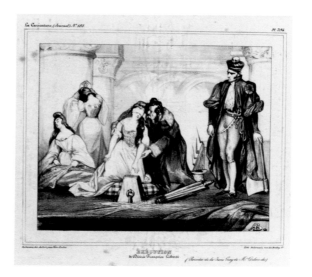

Auguste Bouquet, *Exécution de Désirée Françoise Liberté* (Execution of Désirée Françoise Liberty) Parody of Jane Grey by Mr. Delaroche. *La Caricature*, No. 188, pl. 394, 13 June 1834. Mount Holyoke College Art Museum, South Hadley, Massachusetts.

On the first anniversary of George Bush's State of the Union allegation of Iraqi attempts to purchase yellow cake uranium from Niger, a claim revealed to be false in June 2003, Bell's quartet continues to blindly follow the Yellow Cake Road, headed toward misguided disaster rather than redemption.

A third approach to parodic satire engages in a process of contrasting substitution, in which the negative perception of the satirized subject is at odds with the positive values associated with the original source. As evidenced by Auguste Bouquet's *Ecce Homo!* (page 53) or Pat Oliphant's *Iraq Pietà* (page 74), such works often aim to magnify their targets' faults by placing them in the role of a traditionally revered or solemn figure. When Bouquet depicts the caricatured Louis-Philippe in the role of Jesus Christ presented before his trial, the exposed backside of the king holding an enema

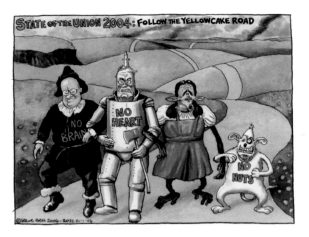

syringe contrasts sharply with the sympathetic treatment of Christ in Rembrandt's original drypoint. Similarly, the childlike form of Oliphant's representation of George Bush undoes the reverence traditionally accorded to the Virgin Mary in pietà images, and the sincerity of her grief is subverted by the disingenuous tone of the work's caption.

Needless to say, the full critical effect of such substitutions will be lost unless the viewer correctly identifies the original work in its parodied state, is familiar with the original subject's characteristics, and can evaluate the parodic satire accordingly. Some parodic caricatures—those with an implicit sense of violence and malevolence, for example—may still convey their meaning, to a degree, independent of the original source. Casati's caricatured image of Louis-Philippe urging a French soldier to attack the sleeping figure of Liberty (*Parodie du tableau de la Clytemnestre*, page vi) carries its own critical impact, but for the full

critique to register, the viewer must first recognize the original source (Guérin's painting *Clytemnestra Hesitating before Stabbing the Sleeping Agamemnon*, 1817) to make sense of the series of substitutions: Liberty for Agamemnon, the soldier for Clytemnestra, and most significantly, Louis-Philippe for Aegisthus, who assumed kingship over Mycenae following the murder of Agamemnon by his treacherous wife. Likewise, without detailed knowledge of the individual personalities developed over the course of six seasons of the HBO televised drama *The Sopranos*, Steve Brodner's critique of the Bush administration (page 79) would fail to carry its full weight. It is not simply that the Bush administration is compared to a group of mobsters, but more significantly that each member of the administration is associated with the particular weaknesses of the flawed individuals making up the cast of characters. Thus, Dick Cheney, and not George Bush, assumes the role of Tony Soprano, the shrewd head of the criminal family, while Bush, depicted as a follower rather than a leader, is transformed into his own version of Christopher Moltisanti, the immature and reckless underling who faithfully carries out Tony's orders.

The original sources for these two parodic satires—a work of high art and a commercialized television franchise—suggest very different things about Casati and Brodner's respective viewers and their assumed familiarity with visual material. If the ideal viewer must first recognize the parodied source to successfully process the critique, source images must remain within the realm of the everyday. As Dwight Macdonald reminds us, "A peculiar combination of sophistication and

provinciality is needed for a good parody, the former for obvious reasons, the latter because the audience needs to be homogenous enough to get the point."[10] Parodic satires, at their most effective, require the selection of source images that are accessible, widely circulated, and familiar to the average viewer. The "average viewer" and the availability of images are, of course, historically and culturally determined. Compared to that of Casati, Brodner's parodic satire has been seen by a greater number of individuals, all of whom have before them a seemingly endless stream of popular images from a range of media. In selecting sources, the caricaturist must therefore consider his audience and the availability of visual imagery at that given moment.

La Caricature's readers would have likely been familiar with the original sources used in the journal's parodic satires through their display at the Salon exhibitions held in Paris, their inclusion in familiar European collections, or their circulation as printed reproductions.[11] Art historian James Cuno's notable work on the readership of Charles Philipon's journals and the clientele at his print shop offers insight into the target audience of the nineteenth-century parodies included in this exhibition. According to Cuno, the location of Philipon's La Maison Aubert, which opened in 1829 and later sold single copies of many of the caricatures printed in *La Caricature* and *Le Charivari*, is a credit to the publisher's awareness of the market and potential clientele. Philipon set up shop near the Palais-Royal on the Right Bank of Paris, one of the city's prime cultural, commercial and upmarket residential areas:

Auguste Bouquet, *Ecce Homo!* (Behold the Man!). *La Caricature*, No. 115, pl. 239, 17 January 1833. Mount Holyoke College Art Museum, South Hadley, Massachusetts.

Philipon and La Maison Aubert's public was, then, one that frequented the promenades, cafes, theaters, and passages of the bourgeois Palais-Royal quarter. It was a public, too, sufficiently familiar with major monuments in the history of art to recognize the numerous references to them in *La Caricature* . . . And it was a public drawn chiefly from the liberal professions, property owners, students, and artists—who could well afford the rather steep subscription fee of fifty-two francs per year when the average worker's daily wage was just over three francs.[12]

As Cuno suggests, Philipon and his caricaturists were clearly targeting and reaching a very select group of readers assumed to be well versed in the masterworks of European art and keen to see them satirically refashioned in the pages of *La Caricature*.

The tradition of high art parodies remains

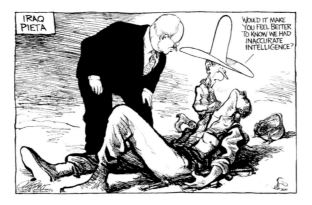

Pat Oliphant, *Iraq Pietà*, 2004. Copyright 2004 Patrick Oliphant. Courtesy of Susan Conway Gallery, Santa Fe, New Mexico, and Washington, D.C.

active, particularly with the UK-based cartoonists featured in the *Guardian*, the *Telegraph*, and the *Independent*. Dave Brown's weekly Saturday feature in the *Independent*, for example, transforms European master paintings into biting and humorous critiques of contemporary politics.[13] Perhaps due to the geographical proximity of the major institutions of European art or the implementation of a free admission policy for national museums in 2001, the British press continues to publish high art parodies as regularly as it does parodies of more popular sources. The long history of high art parodies within English visual satire has resulted in the continuing popularity of many of the same sources adopted by eighteenth-century British caricaturists, among them Henry Fuseli's *Nightmare*, 1781 (see Nicholas Garland, *America's Nightmare*, page 77).[14]

While American newspapers do not publish high art parodies with the same frequency as their British counterparts, contemporary American illustrators have found a market for such work within specialized magazines. For example, Edward Sorel's *Grand Delusion*, which parodies the central figural group in Benjamin West's *The Death of General Wolfe*, 1770, originally served as an illustration for an August 2007 *Vanity Fair* article on the Bush administration's attempts to reframe its historical legacy in the final months of the presidency.[15] Drawing on the allusion to traditional Christian imagery of the Lamentation of Christ seen in West's painting (a work that received a good deal of attention for its own historical revisionism), Sorel's image replaces the original pyramid of aides gathered around the British general with representatives of Bush's inner circle, tending to the wounded president as he feebly fingers a "Mission Accomplished" banner. The parodied source in Sorel's image is a major work of the eighteenth century, to be sure, but its recognition nevertheless requires a certain level of art-historical knowledge.

Visual sources parodied in American newspapers typically draw from works of art that are more popularly known, often through their commercial reproduction (as posters, for example) and/or their inclusion in the collections of highly visited museums. If an American newspaper editor faced with a much broader demographic of the American public than *Vanity Fair* might be reluctant to sign off on a parodic satire of an eighteenth-century European painting, more accessible sources do make the cut. Several works by American cartoonists included in this exhibition parody canonical images that are familiar even to viewers with limited knowledge of art history, among them Salvador Dali's *The Persistence of Memory*, 1931 (Nick Anderson, *Wilting in the Heat*), and representations of the pietà, most famously known through Michelangelo's *Pietà*, 1499 (Oliphant, *Iraq Pietà*).[16]

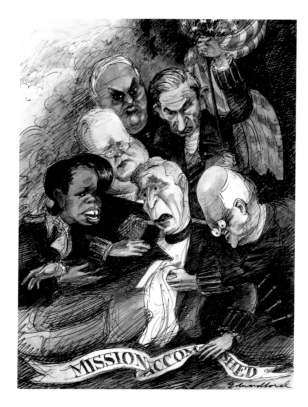

While these examples are testament to the continued, if selective, presence of high art parody, contemporary parodies more consistently look beyond the walls of the museum for sources. Many of the parodic satires included in the exhibition draw from press photographs, television shows, movies, and other areas of popular culture: *The Wizard of Oz* (Bell, *Yellow Cake Road*, page 18, and Drexel Dwane Powell, *The Men Behind the Curtain*, page 23), *The Sopranos* (Brodner, *The Bushanos*, page 79), *Brokeback Mountain* (Mark Ulriksen, *Watch Your Back Mountain*, page x), and news images (Bell, *Al Who'Da??* and *Bush Throat Job*, page 16 and page 68). If the collective bank of shared images seems to be expanding in the final decades of the twentieth century, this may be the result of what we take in on an average day. The constant presence of television sets—not just in living rooms but in lobbies, waiting rooms, airports, taxi cabs, restaurants, and bars—and the immediate access to the internet has led to a barrage of recognizable images being circulated within today's culture. On average, Americans watch four hours and thirty-five minutes of television daily, and the American home has a television turned on (not always with someone tuned in) for just over eight hours a day.[17] Estimates from 2005 place the number of television sets in America at 285 million; by comparison, 38 million people visited the two hundred largest American art museums in 2008.[18] If the cultural institutions of the Palais-Royal quarter were the reference point for the readers of *La Caricature*, the contemporary parallels might now be HBO, MTV, and CNN. The average American, then, might indeed recognize Tony Soprano more readily than Titian.

The popularity of news images within

Edward Sorel, *Grand Delusion*, 2007. Copyright Edward Sorel.

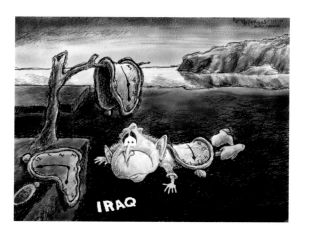

Nick Anderson, *Wilting in the Heat*, 2008. Copyright Nick Anderson/The Houston Chronicle.

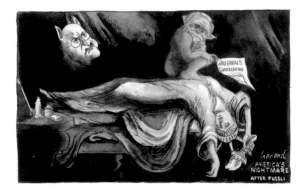

contemporary parodic satires is not surprising considering the visibility of the source material and its continuous circulation in the print media, on television, and throughout the internet. Viewer studies estimate that 22.8 million Americans tune in to network news programs nightly, with an additional 3.64 million viewers watching primetime cable news. Combined with the median daytime news viewership (1.86 million in 2008), American news programs pull in a *daily* audience of 28.3 million Americans, just 9.7 million less than the *annual* attendance totals for U.S. museums during the same year.[19] News images, shown nightly on TV screens across the nation, have come to replace the master paintings of the Renaissance as the most effective sources for parodic satires.

Images circulated on news programs and in the print media can include a range of cultural subjects, but the most frequently parodied are often photographs of war or wartime events. Historically quick to imprint themselves on the popular memory, war images carry a unique potential for widespread recognition. More than two and a half years after the September 11 attacks, Nicholas Garland, like Steve Bell, parodied the news footage of Andrew Card informing George Bush of the second plane hitting the Twin Towers, a testament to the long-term recognizability of wartime images.[20] Addressing the power of war photography, Michael Hill writes:

> The images are engraved onto the memory, pictures that become powerful summations of the nation acting in extremis—going to war . . . A deluge of images of the war in Iraq compete for that iconic status: an American soldier carrying a wounded Iraqi enemy, a statue of Saddam Hussein tumbling down, a triumphant President Bush in a fighter pilot's uniform, a despondent Hussein undergoing a dental exam, burned bodies hanging from a bridge in Fallujah, rows of flag-draped coffins in a military transport plane, a hooded Iraqi prisoner standing on a stool, his body apparently wired for electricity.[21]

Of the Iraq War images mentioned by Hill, nearly all are the subjects of cartoons from across the globe. While elements of the photographs often appear as part of a larger scene (Gerald Scarfe, *How the Hell did That Get Here?* and *My Election Chances*, page 67 and page 71), many are reworked into parodic satires at the expense of George Bush (Bell, *Al Who'Da* and *Bush Throat Job*, page 16 and page 68). Timely, recognizable, and dramatic on account of their original context, images of war are a powerful tool in the hands of the parodist.

The mass marketing of television programs and Hollywood films likewise has the potential to turn images into popular icons. The considerable press given to critically successful films

provides contemporary cartoonists with a continuous stream of subjects ripe for parody. The *New Yorker* published Mark Ulriksen's *Watch Your Back Mountain* (page x), a parody of the press poster for the film *Brokeback Mountain*, in late February 2006, just eleven days after the infamous hunting incident in which Dick Cheney accidentally shot Texas attorney Harry Whittington. The image of Cheney coolly blowing the smoke from the barrel of his shotgun as Bush peers out over his shoulder was doubly effective due to the timeliness of the source material. Following the December 2005 release of *Brokeback Mountain*, the film's depiction of the secret love affair between two cowboys was widely discussed, with media outlets of every form offering opinions. At a January 2006 question-and-answer session following a televised address at Kansas State University, the president was unwillingly brought into the debate when asked about the movie. Evidently embarrassed, Bush repeatedly stated that he hadn't seen the film before gesturing for the next question with a considerable display of irritation.

The *New Yorker* cover's success as a parodic satire lay in bringing together a range of subjects—the president's public distancing of himself from the film, his cultivated cowboy persona, Cheney's hunting incident, the fraternal atmosphere and air of secrecy that commonly characterized the Bush administration—into a single visual dialogue, using one of the most parodied sources of the moment to do so. When Ulriksen's image appeared on the *New Yorker* cover, *Brokeback Mountain* was in its widest release, playing on more than two thousand screens, and had won a Golden Globe award several weeks earlier. With

12.6 million theater viewers and over 120 award nominations, *Brokeback Mountain* became an instant source for printed and live parodies drawing on the film's poster, clips, and memorable lines. Even those who had never seen the movie easily recognized the references and were quickly let in on the joke.

Critics likewise responded to Ulriksen's satiric parody, with the American Society of Magazine Editors and the Magazine Publishers of America awarding him the 2006 Best News Cover Award, praising his depiction of "the smugness of a vice president implicated in catastrophe and the cluelessness of a president incapable of stopping him."[22]

The popular response to parody is equally evidenced by the reproduction of Brodner's *Bushanos* as a poster available for purchase and as a foldout feature in *Freedom Fries*, the 2004 publication of Brodner's political caricatures. While attention duly paid to Ulriksen's and Brodner's images suggests the growing breadth of culturally recognizable imagery within the United States, the high art parodies featured in British newspapers and American magazines speak to the enduring

presence of eighteenth- and nineteenth-century satirical traditions, in which centuries-old images can still forcefully affect the reception of modern politics. With the digitization of museum collections and the popularity of online blogs and photo collections, high art has become increasingly accessible to the public, instantly available with a few simple keystrokes. Just as the masterworks of European painting once circulated in eighteenth-century London or nineteenth-century Paris as printed reproductions, they can now be endlessly duplicated in digital form alongside images from the news media, film, and television. Titian might then return to join Tony Soprano rather than be trumped by him, expanding the popular possibilities for the clever caricaturist in search of parodic inspiration.

NOTES

1. When asked to submit the photos they felt best summed up President Bush and his administration for Errol Morris's featured blog on the *New York Times* website, the head photo editors of the wire services the Associated Press, Reuters, and Agence France-Presse all included a variation of the Bush-Card photo. Errol Morris, "Mirror, Mirror on the Wall," *Zoom*, 25 January 2009, morris.blogs.nytimes.com.

2. I take my use of the term parodic satire from Linda Hutcheon, who defines it as a form of satire that "aims at something outside the text [e.g., the policies and character of a political figure], but which employs parody as a vehicle to achieve its satiric or corrective end." The correlate to this would be a satiric parody: "a *type* of the *genre* parody . . . which is satiric, and whose target is another form of coded discourse." Linda Hutcheon, *A Theory of Parody* (New York: Methuen, 1985), p. 62. A contemporary example of satiric parody would be *The Colbert Report*'s critique of the news media format.

3. Auguste Bouquet, *La Cène*, parody of Leonardo's *Last Supper*, La Caricature 81, 17 May 1832; C.J. Traviès, *Hercule vainqueur*, parody of the Farnese Hercules, La Caricature 182, 1 May 1834; Anonymous, *Le Chat, la belette et le petit lapin (Fable)*, parody of La Fontaine's fable of the same name, La Caricature 235, 17 July 1834.

4. A full summary of the literature is beyond the scope of this essay; however, the most significant among twentieth-century studies include Hutcheon, *A Theory of Parody*; Margaret Rose, *Parody//meta-fiction* (London: Croom Helm, 1979); Gérard Genette, *Palimpsestes: la littérature au second degré* (Paris: Seuil, 1982). For a useful gloss of the various opinions present in the literature, see Hutcheon, *A Theory of Parody*, Chapter One.

5. Gilbert Highet, *The Anatomy of Satire* (Princeton, NJ: Princeton University Press, 1962), p. 68. The Oxford English Dictionary includes this criterion among its definitions of parody: "A composition in prose or verse in which the characteristic turns of thought and phrase in an author or class of authors are imitated in such a way as to make them appear ridiculous, especially by applying them to ludicrously inappropriate subjects."

6. This sentiment is echoed by Hutcheon, who argues, "Satirists choose to use parodies of the most familiar texts as the vehicle for their satire in order to add to the initial impact and to reinforce the ironic contrast . . . the ethos of the parody was not negative, even if that of the satire was." *A Theory of Parody*, p. 588. On the roots of parodic satire in the political cartoons of eighteenth-century England, see Diana Donald, *The Age of Caricature: Satirical Prints in the Reign of George III* (New Haven: Yale University Press, 1996), pp. 67–72.

7. Hutcheon, *A Theory of Parody*, p. 100.

8. Not all parodic satires present a full stylistic distortion, however. The parodic satires of *La Caricature*, for example, often caricature the figure of Louis-Philippe while retaining significant portions of the original works' artistic style. This may be due in part to the works' connection to eighteenth- and early nineteenth-century French conceptions of literary parody, in which a substitution of subject matter takes place with little or no modification of the original style. See Genette, *Palimpsestes*, pp. 21–22.

9. Louis-Philippe appears as Judas to Liberty's Jesus

in Bouquet's parody of Leonardo's *Last Supper* (see note 3) and the anonymous parody of Anthony van Dyck's *Betrayal of Christ* (see note 11).

10. Dwight Macdonald, *Parodies: An Anthology from Chaucer to Beerbohm—and After* (New York: Random House, 1960), p. 567.

11. Parodied works exhibited at the Salon or in French collections include: Titian, *Christ Crowned with Thorns*, entered Louvre collection in 1797 (parodied by Traviès, *La Caricature* 169, 30 January 1834); P.-J. Prud'hon, *Justice and Vengeance Pursuing Crime*, Salon of 1808, entered Louvre collection in 1826 (parodied by A. Casati, *La Caricature* 171, 13 February 1834); Pierre-Narcisse Guérin's *Clytemnestra Hesitating Before Stabbing Agamemnon*, Salon of 1817, entered Louvre collection in 1819 (see page vi); Horace Vernet's *Massacre of the Mamelucks in Cairo*, Salon of 1819 (parodied by Grandeville, *La Caricature* 179, 10 April 1834); Eugène Devéria, *Birth of Henry IV*, Salon of 1827 (parodied by Grandeville, *La Caricature* 66, 2 February 1832); Delacroix's *Christ in the Garden of Olives*, Salon of 1827, then Church of St. Paul-St. Louis, Paris (parodied by Bouquet, *La Caricature* 91, 2 August 1832); Paul Delaroche's *The Execution of Lady Jane Grey*, Salon of 1834 (see page 56). Parodied works displayed elsewhere in Europe include: Bruegel the Elder, *Parable of the Blind Men*, Naples (parodied by Desperret, *La Caricature* 136, 13 June 1833); van Dyck's *Betrayal of Christ*, Prado, Madrid (anonymous parody, *La Caricature* 97, 13 September 1832), and the Farnese Hercules, Naples (see note 3). Parodied works originally produced in printed form include: Rembrandt, *Ecce Homo* (parodied by Bouquet, *La Caricature* 115, 17 January 1833, see page 53).

12. James Cuno, "Charles Philipon, La Maison Aubert, and the Business of Caricature in Paris, 1829–41," *Art Journal* 43 (Winter 1983), p. 349. *Le Charivari* cost sixty francs for an annual subscription. Both journals were available at public reading rooms as well, many of which were located in the same quarter as Philipon's shop and attracted a predominately bourgeois clientele.

13. Selections of Dave Brown's series for the *Independent* are reproduced in two recent publications, *Rogues' Gallery* (2007) and *Rogues' Gallery: More Misused Masterpieces* (2009).

14. See Donald, *The Age of Caricature*, pp. 69–71.

15. See David Halberstam, "History Boys," *Vanity Fair*, August 2007, pp. 122–69.

16. Pat Oliphant's Pulitzer Prize-winning cartoon, "They Won't Get Us to the Conference Table . . . Will They?" (*Denver Post*, 1 February 1966) also employed the image of the pietà, more directly drawing from Michelangelo's sculpted version.

17. "Average Home has More TVs Than People," *USA Today*, 21 September 2006, www.usatoday.com.

18. Television statistics are taken from Consumer Electronics Association, "New Data Shows Analog Broadcasting Cut-Off Will Impact Few U.S. TV Sets and Homes," 6 June 2005, www.ce.org. Museum attendance statistics are taken from Robin Cembalest, "Reshaping the Art Museum," *ARTnews*, June 2009, p. 76.

19. Television statistics are taken from Pew Project for Excellence in Journalism, "State of the News Media 2008: An Annual Report on American Journalism," 16 March 2009, www.stateofthemedia.org.

20. See Nicholas Garland, *9.11.2007*, as well as Garland, "The Moment Bush was Told the Shocking News," *Daily Telegraph*, 29 April 2004.

21. Michael Hill, "Defining Images: How a Picture Becomes an Icon of War," *Baltimore Sun*, 9 May 2004. W. J. T. Mitchell's forthcoming analysis of the news imagery of the Iraq War will add greatly to this discussion. "Cloning Terror: The War of Images, 9-11 to Abu Ghraib," in *Beauty: The Ethics of Aesthetics*, ed. Diarmud Costello and Dominic Willsdon (London: Tate Gallery Publications, forthcoming).

22. "2006 Best News Cover Winner and Finalists," *American Magazine Conference E-Newsletter*, 22 October 2006, www.magazine.org.

Noble Savage or Naughty Monkey?

Primitivism and
Portrayals of the George
W. Bush Presidency

Alexis Clark

PARODYING HUMANS AS PRIMATES has historically operated as a metaphor, visual shorthand to represent social distrust or disgust. This convention extends from the early Christians to the present day, when cartoonists such as Pat Bagley, Pat Oliphant, Steve Bell, Martin Rowson, and Gerald Scarfe have portrayed President George W. Bush as primate-in-chief. Over the course of his presidency, Bush's cartooned image evolved from bumbling but still human, to cutesy chimp, and finally to sinister "monkey-man." He was thus visualized as the proverbial monkey-in-the-middle, occupying a precarious position between humanity and bestiality. Some cartoons seem almost playful in their depictions of Bush as an ignorant *naïf*. Others, though, skewer the president as malevolent and mischievous, and consequently contort his appearance to resemble that of a simian brute. Ultimately, these cartoonists distort Bush's physiognomy to draw attention to the perceived shortcomings of his person and policies.

Primate parodies have typically connoted unchecked carnal desires and barbarism. Early Christians in the second to fourth century chastised the unorthodox as *simia*, for instance, and in the Middle Ages monkeys were likewise used to refer to the rejection of the spiritual.[1] Use of primate metaphors slowly shifted from signaling ideological disapproval to reinforcing ethnic and racial stereotypes. Eighteenth-century racial theory and aesthetics equated physical beauty with moral rectitude. A beautiful face reflected a beautiful soul. Dutch naturalist and physician Pieter Camper (1722–1789) compared facial angles and measurements of different races, and tied intelligence to cranial size. Placing these angles on a spectrum of beauty and perfection, he contended

that Europeans' heads recalled the god Apollo whereas Africans' heads resembled those of apes.[2] German art historian Johann Joachim Winckelmann (1717–1768) similarly identified the ancient Greeks with a perfect beauty, which he claimed they attained through their temperate climate, democratic government, and physical exercise. That perfection was in turn reflected in their sculpture.[3]

Such racism pervaded not only comparisons between Europeans and non-Europeans but between different populations within Europe. Nineteenth-century English caricaturists, for instance, fearful of the influx of recent immigrants and agitation for home rule, showed the Irish as slovenly gorillas with snubbed noses, grizzly muzzles, and hunched shoulders, in effect casting them as the simian "other." In the 1881 *Punch* cartoon *Two Forces*, John Tenniel represents subversive Irish anarchists as a hairy, oafish monkey-man whose open mouth reveals jagged teeth, pitting him against Britannia, a regal and quasi-divine figure with a stalwart expression, helmet, and flowing, classically inspired peplos. Shielding the greater Irish population, here depicted as the cowering female figure Hibernia, from Irish anarchism, Britannia boldly confronts the rogue, brandishing a sword against his rock. Though in this example the Irishman's tattered cap hides his forehead, many cartoonists drew the Irish with noticeably lower foreheads than their English counterparts, in turn reinforcing their supposed intellectual inferiority.[4] Such comparisons between the Irish and primates were timely: only in the mid-century were gorillas identified as a distinct species and introduced to English zoos.[5] In 1859, Charles Darwin's watershed *The*

Origin of Species led to scientific and political debate over possible similarities between mankind and monkeys.[6]

From the end of the nineteenth century until the present day, monkeys have continued to illustrate symbolic threats to civilization through their associated characteristics of lust and brutality. In 1887, for instance, the French sculptor Emmanuel Frémiet displayed his *Gorilla Abducting a Woman* with its slobbering, slack-jawed primate who holds hostage a writhing and naked woman.[7] This theme of monkey lust reappeared in First World War propaganda such as H. R. Hopps's American army recruitment poster *Destroy This Mad Brute* (1917) depicting another half-naked woman kidnapped by a snarling simian (page 28). Accoutrements, the spiked *pickelhaube* helmet and club labeled "kultur," identify the gorilla as an embodiment of German troops and thus a potential threat to the United States. More recently, in 2005, cinematic audiences watched an oversized gorilla scale the Manhattan skyline in search of his paramour in the latest King Kong film.[8]

Cartoonists readily integrated this connection between primates and destruction in their images of George W. Bush. They distorted the president's physiognomy to symbolize his perceived intellectual shortcomings: low, furrowed brow; squinting eyes; enlarged ears; heavily outlined lips; and squat torso with stooped shoulders or drooping arms. In keeping with its use in earlier visual culture, the monkey suit operated to isolate him from his fellow humans and from civilization, thus calling into question his basic humanity. There were subtle but nonetheless significant twists to the way cartoonists depicted Bush. Historically, the visual arts have frequently portrayed

Sir John Tenniel, *Two Forces. Punch*, 29 October 1881.

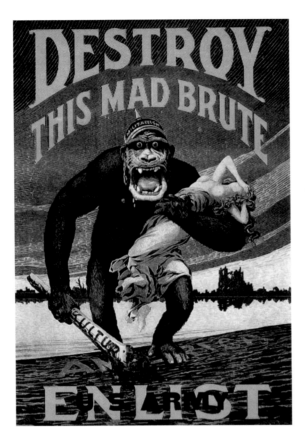

H. R. Hopps, *Destroy This Mad Brute*, 1917. Harry Ransom Humanities Research Center, the University of Texas at Austin.

racial, ethnic, and ideological minorities as primitive, presenting non-Western subjects as different, backward, and ultimately "other." This has especially been the case in depictions of people from Africa, pre-Columbian America, and the Middle East—the same place that the president supposedly sought to wrest from terrorism.[9] From 2000 to 2008, caricaturists in the United States and Europe did not entirely eschew stereotypes of the Middle East, nor did they limit parodies of the president to scathing monkey metaphors, often portraying him in other, nobler guises: the

tough-talking cowboy or crusader atop his trusty steed. But differences quickly surface.[10] Wranglers and warriors have been made into popular heroes; primates have not. The former have been associated with chivalry and self-sacrifice, while monkeys represent humans' regression to an earlier developmental state. Unlike those of cowboys and crusaders, the depictions of America's political leader as a primate, as the truly brutish and backward "other," sought to divide the American public from their president.

There exists one important precedent for the depiction of a national leader as primitive—Louis-Philippe. The Pear and Gargantua may be the most infamous examples of political caricature from the July Monarchy, yet *Le Charivari* and *La Caricature* cartoonists envisioned Louis-Philippe not only as rotten fruit or a flatulent behemoth but also as an ignoble savage. In *Le Jongleur* (The Juggler, see page 57), for example, J. J. Grandville portrays the king as a street performer in Native American dress with a foliate skirt, armbands, and a feathered headdress, and tattooed with a sunburst, relying on the then commonplace association of Indians and savages to plant his barb. Pistol, knife, book, and bag—symbols of order, justice, economy, and the constitutional Charter—have been simultaneously thrown into the air. These objects just escape the reach of the paunchy Louis-Philippe and will eventually fall on the nearby owl, the traditional symbol of wisdom. The French national emblem—the Gallic cock—has been chained to the stage, held hostage like the French people who were captives of an increasingly authoritarian king. Grandville's *Jongleur* thus suggests that the July Monarchy stage-show will inevitably come crashing down.

Just as this image shows the French monarch juggling his promises and responsibilities, so Bush was presented as similarly devious. Pat Oliphant's *On the Road* (page 30)—a parody of the president as a naked toddler cowboy on a tricycle wheeling away from the chain of evolution—was inspired by Bush's remarks on whether intelligent design should be taught alongside evolution in science classrooms. He stated that students should explore different theories but stopped short of endorsing intelligent design as an alternative to evolution.[11] While not portraying a monkey or even subhuman figure, Oliphant's cartoon suggests that the president remains a child, stuck in an earlier developmental stage. Misshapen and then simian creatures bubble up from a nearby swamp and become increasingly humanoid. Two simians discuss the president's decision to take a separate course on this evolutionary path, hinting that his intellectual course has taken a similarly sharp turn from the mainstream. Oliphant here touches on an important theme within the physical and intellectual primitivism of Bush—the belief that the president suffered from an almost childish intellectual stubbornness that often led him to chart a separate and at times divisive course. Even monkeys, in deciding to remain on the path of evolution, possess more intelligence, Oliphant seems to suggest.

Whereas Oliphant depicts Bush as infantile in stature and logic, Pat Bagley caricatures him as childishly naïve, a follower rather than a leader, in *Clueless George Is Watching You!* (page 31). Spoofing H. A. Rey's *Curious George* books, the cartoon offers more than a clever pun on the president's name. Unlike the bedtime stories, here no one rescues Curious or, in this case, Clueless George W. Bush

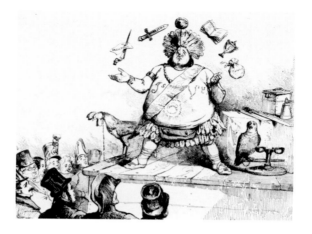

J. J. Grandville, Eugene-Hippolyte Forest, *Untitled (Le Jongleur, sauteur, banquiste et prestidigitateur* (The juggler, unreliable fellow, charlatan, and magician). *La Caricature*, No. 224, pl. 467, 5 May 1835. Mount Holyoke College Art Museum, South Hadley, Massachusetts.

from catastrophe. And no one swoops in to save the reader or the public from his implied misdeeds. Cutesy in its depiction of a smirking chimp spying through a keyhole, *Clueless George Is Watching You!* captures the president's endorsement of the USA Patriot Act (2001) and the Homeland Security Act (2002), which granted the federal government widespread permission to record telephone conversations, check electronic correspondence, and track other records in order to prevent another terrorist attack.[12] The Acts unleashed a storm of debate as critics contended that it provided the government with unprecedented and even unconstitutional power.[13] In his subsequent illustrated storybook also named *Clueless George Is Watching You!* Bagley implies that the Act's wiretapping, surveillance, and detention measures were masterminded by the imperious vice president, and that the president, though somewhat simpleminded and certainly led astray, might have been far from innocent.[14]

Questioning this conflation of ignorance and innocence, British cartoonist Steve Bell, while also interested in the theme of evolution, fully

Pat Oliphant, *On the Road*, 2005. Copyright 2004 Patrick Oliphant. Courtesy of Susan Conway Gallery, Santa Fe, New Mexico, and Washington, D.C.

anthropomorphized the president. His *Ascent of the Chimp Part 2* (page 80) chronicles a series of slow shifts in Bush's presidency and identity. Unlike the Oliphant cartoon of evolution with its image of the president frozen in a state of childish naïveté, Bell uses evolution to suggest that Bush has regressed. The president wears a variety of costumes, from military general, to Darth Vader wannabe with his cape and assisted breathing device, to lame duck with crutches and bandaged foot. In all but this final transformation, Bell depicts Bush as simian—slouched posture, funneled lips, and hands dragging on the ground. At the far left, and so presumably at the beginning of his presidential term, Bush appears relatively human and official in his suit and tie. By the end of his presidency, however, he has been completely transformed. This movement from left to right suggests that as Bush spent more time in office, he became ever more lame and crippled in his capacity to lead the nation.

Bell also persistently and directly mocks Bush's perceived intellectual shortcomings in his failure to master language—quite possibly the most obvious division between humankind and animals.

Cartoon speech bubbles parody the president's much publicized difficulties in pronunciation, rendering his voice and thus any message as garbled with make-believe words and mixed metaphors. In his awkward oratory, Bush is depicted as a brute—spluttering without communicating. Bell could easily have taken his inspiration from so-called Bushisms—like his confusing query whether "highways on the internet will become more few."[15] *AirForce-Yurp* (page 32), with its mispronunciation of "Europe," underscores the difficulties Bush confronted beyond America's borders, playing on his perceived isolation and reflecting the more general opposition to the president in Europe, where, aside from Great Britain, there was little commitment to the war in Iraq.[16]

Support for the president in Europe slid as the conflict in Iraq became associated with the Abu Ghraib scandal and the execution of Saddam Hussein. An Associated Press public opinion poll recorded that by February 2004, only 27 percent of Britons viewed Bush positively.[17] In November 2006 the *Guardian* reported on Britons' increased frustration over the continued violence and failed rebuilding projects in Iraq.[18] Martin Rowson's 7 November 2006 cartoon *Vote Early! Vote Often!* also published in the *Guardian*, treated the execution of Saddam Hussein as a crass political gimmick, with Rowson suggesting that the Bush administration hoped to translate the trial of the ex-dictator into votes. The former Iraqi leader was sentenced to death on 5 November 2006, two days before Americans went to the polls for midterm congressional elections. The cartoon asserts that Americans had a choice: they could support this form of justice-by-death or challenge

an administration associated with human rights abuses and "enhanced" interrogation tactics. Rowson conflates Bush with Saddam's executioners as the president, drawn with all the typical characteristics of a primate—devilishly pointy ears, close-set eyes, stumpy torso, and stretched limbs—dangles from the rope used to hang the deposed dictator. Clicking his heels in a presumed gesture of glee, he victoriously waves a frayed American flag. Yet the threadbare state of the flag raises a pertinent question: victory at what cost? The cartoon implies that the nation's reputation had been tarnished alongside that of its simian leader, while the deep red backdrop further connotes the ravenous, demonic, and bloodthirsty characteristics that Rowson associates with the president.

Cartoonists Pat Oliphant, Pat Bagley, Steve Bell, and Martin Rowson placed Bush on a broad spectrum of monkeydom, thereby questioning whether he was misguided in his intentions, or diabolical in his policies. Bagley and Oliphant caricatured him as a relatively innocent chimp, a *naïf* whose misdeeds could be attributed to ignorance and treacherous advisors. By comparison, British cartoonists Bell and Rowson transformed Bush into a vile, loathsome "monkey-monster," who incarnated the "values of ignorance, stupidity and arrogance."[19]

This simian imagery surfaced at a crucial point in American domestic and foreign policy. As a presidential candidate in 2000, Bush had campaigned on "compassionate conservatism" at home and humility abroad. After the election, and especially after 9/11, the rhetoric shifted to reflect the president's new mission to protect America

from future terrorist attacks.[20] The administration continued to promote the president and his policies as noble and virtuous, while at the same time it described potential enemies to American national security with such polarizing phrases as "Axis of Evil" and "evildoers."[21] For a number of cartoonists, however, the president became an embodiment of the very brutalism he sought to oppose. The cartoon monkey suit characterized Bush as lacking basic human qualities—language, intellect, and compassion. Ultimately, these cartoonists portrayed the president as a monkey to question not merely whether he was human, but whether his policies were humane.

NOTES

1. H. W. Janson, *Apes and Ape Lore in the Middle Ages and the Renaissance* (London: The Warburg Institute, 1952), pp. 14–19, 29.

2. David Bindman, "Mankind after Darwin and Nineteenth-Century Art," in *Endless Forms: Charles Darwin, Natural Science and the Visual Arts*, eds. Diana Donald and Jane Munro (New Haven: Yale University Press, 2009), p. 144. See also David Bindman, *Ape to Apollo: Aesthetics and the Idea of Race in the 18th Century* (Ithaca, NY: Cornell University Press, 2002), pp. 190–222.

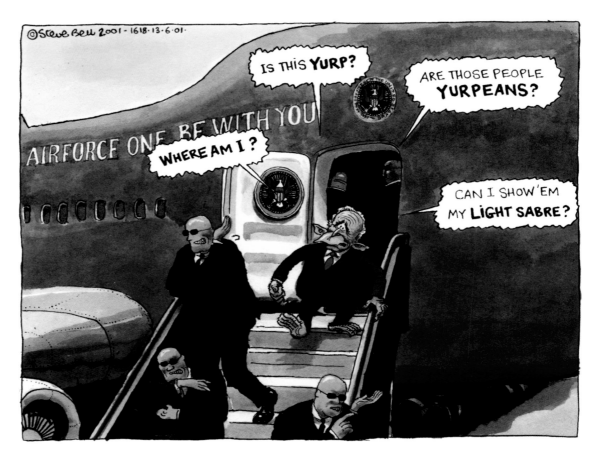

3. Bindman, *Ape to Apollo*, pp. 79–83.

4. L. Perry Curtis, *Apes and Angels: The Irishman in Victorian Caricature* (Washington, D.C.: Smithsonian Institution, 1971), pp. 94-95, 105.

5. Julia Voss, "Monkeys, Apes and Evolutionary Theory: From Human Descent to King Kong," in *Endless Forms*, p. 216.

6. Voss, "Monkeys, Apes and Evolutionary Theory," p. 215. Charles Darwin, *On the Origin of Species by Means of Natural Selection* (London: John Murray, 1859).

7. Emmanuel Frémiet, *Gorilla (Troglodyte gorilla from Gabon) Abducting a Woman*, 1887, Musée des Beaux-Arts, Dijon.

8. Cartoonists used these visual culture precedents to inform their work. Mike Luckovich, for instance, used the King Kong theme to depict the president as a gorilla suspended from one of the World Trade Center towers; see his *Four More Wars!!!* (Toronto: ECW Press), p. 12.

9. In *Orientalism* (London: Penguin Books, 1978), Edward Said traces how Middle-Eastern countries have historically been defined only through negative comparisons with Western customs and beliefs, leading to erroneous perceptions of the region as backward or "other." Western artists have tended to visualize the Middle East through culturally conditioned stereotypes—for instance, as a dusty land of snake charmers

and soothsayers, or as a place where crumbling monuments subtly signal moral corruption. For an overview of Orientalism in art, see John MacKenzie, *Orientalism: History, Theory and the Arts* (Manchester: Manchester University Press, 1995).

10. For examples, see Roman Genn, *Here We Go Again: Islam and the West*, cover illustration of the *National Review*, 3 December 2001; Roman Genn, *Reining in the Courts*, cover illustration of the *National Review*, July 2002; and Pat Oliphant, *Iraq Pietà*, 12 July 2004 (page 74).

11. Elisabeth Bumiller, "Bush Remarks Roil Debate on Teaching of Evolution," *New York Times*, 3 August 2005. See Andrew J. Petto and Laurie R. Godfrey (eds.), *Scientists Confront Intelligent Design and Creationism* (New York: W. W. Norton, 2007).

12. For information on the USA Patriot Act, see Herbert Foerstel, *The Patriot Act: A Documentary and Reference Guide* (Westport, CT: Greenwood Press, 2008). To read the Homeland Security Act, see http://www.dhs.gov/xabout/laws/law_regulation_rule_0011.shtm.

13. For one example, see William Safire, "You are a Suspect," *New York Times*, sec. A, 14 November 2002. Though critics complained that the USA Patriot Act and Homeland Security Act curtailed civil liberties, the Bush administration repeatedly defended it. In February 2005, Bush called for a renewal of the Patriot Act. Though the Act was scheduled to expire at the end of 2009, Congress has recently considered whether to extend or modify provisions regarding roving wiretaps and the seizure of tangible items potentially related to terrorist activities such as diaries and computers.

14. Pat Bagley, *Clueless George Is Watching You!* (Salt Lake City, UT: Whitehorse Books, 2006). Pat Bagley has published several books in this series. See Pat Bagley, *Clueless George Takes on Liberals!* (Salt Lake City, UT: Whitehorse Books, 2007).

15. Bob Herbert, "In America; Political Tongue-Twisters," *New York Times*, sec. A, 28 August 2000.

16. The Coalition of the Willing included a limited number of European troops from Albania, Bosnia and Herzegovina, Bulgaria, the Czech Republic, Denmark, Estonia, Hungary, Iceland, Italy, Latvia, Macedonia, Moldova, the Netherlands, Norway, Poland, Portugal, Romania, Slovakia, and Spain. Even before the invasion of Iraq, the news media documented the international debate over intervention in Iraq. For an example, see Brian Knowlton, "Bush Warns UN to Act on Iraq Now or Face Irrelevance: But Russia, China and France Continue to Oppose U.S. and U.K.," *New York Times*, 4 October 2002.

17. For opinion polls on Iraq and other topics, see http://surveys.ap.org/.

18. British journalists highlighted how the Saddam Hussein verdict coincided with the American elections as well as increased public criticism of the war. Martin Wollacott, "Rising to the Challenge," guardian.co.uk, 6 November 2006.

19. See Steve Bell interview, "Steve Bell on George Bush," *Guardian*, 16 January 2009, http://www.guardian.co.uk/world/interactive/2009/jan/15/steve-bell-george-bush.

20. In a 2006 town hall meeting, the president explained how times had changed, and in response how worldviews must change as well: "When I was growing up, or other Baby Boomers here were growing up, we felt safe because we had these vast oceans that could protect us from harm's way. September the 11th changed all that. And so I vowed that we would take threats seriously." For an extensive discussion on the Bush administration's rhetorical strategies, see Colleen Elizabeth Kelley, *Post-9/11 American Presidential Rhetoric: A Study of Protofascist Discourse* (Plymouth, UK: Lexington Books, 2007), p. 224.

21. Bush referred to North Korea, Iran, and Iraq as the "Axis of Evil" in his 2002 State of the Union address. Phrases like "evildoers" and "dead or alive" were used to refer to terrorists shortly after the 9/11 attacks. Kelley, *Post-9/11 Rhetoric*, pp.197–240. Kelley considers how the administration used moralizing, even fundamentalist Christian, rhetoric grounded in fear to secure support. This, she argues, essentially pitted "good" Bush supporters against his bad or possibly even evil naysayers.

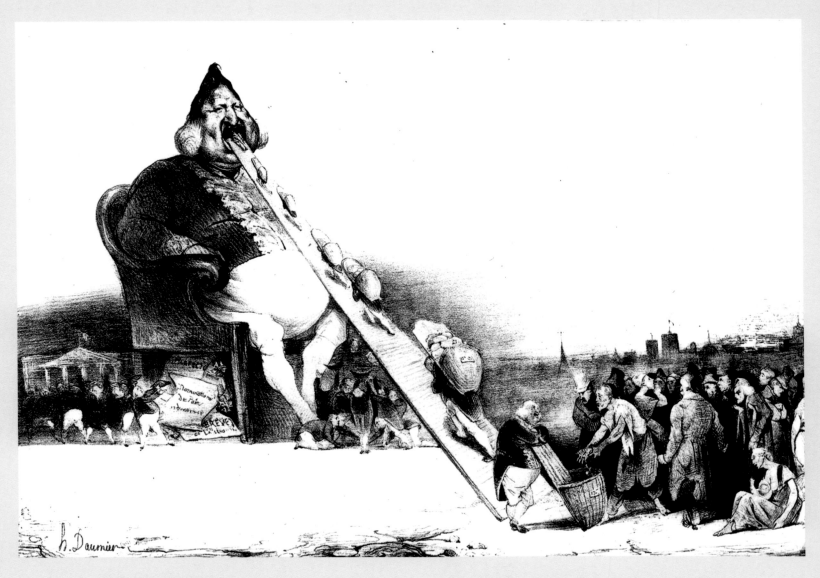

Honoré-Victorin Daumier, *Gargantua,* 1832. Benjamin A. and Julia M. Trustman Collection of Honoré Daumier Lithographs.
Robert D. Farber University Archives & Special Collections Department Brandeis University.

ONE MIGHT ASSUME that draconian censorship laws are the most effective way to suppress subversive humor. However, the comparison afforded by this exhibition demonstrates how cultural norms can temper political dissent more effectively than legal regulations. A visitor to this exhibition could conclude that contemporary American political cartoonists are more respectful of political leaders than their international counterparts and nineteenth-century French antecedents. American caricatures tend to infantilize the president or employ parody, anthropomorphism, or metaphors to make political statements. While the dung-eating kings of Honoré Daumier and Charles Philipon and the rabid apes drawn by contemporary British artists Steve Bell and Gerald Scarfe seem designed to degrade the subject, the naughty monkeys, cowboys, and thugs drawn by American artists seem designed to taunt the target of scorn. By and large, the American images are more *amusing* than images from nineteenth-century France and the contemporary United Kingdom, which frequently employ scatology, horrific imagery, and the grotesque.

This hint of restraint in American cartoons invites further inquiry into the circumstances of their creation. I would suggest that the moderation shown by contemporary American caricaturists owes little to state-sponsored suppression and nothing to respect for authority or an inherent timidity. Instead, nongovernmental pressures on content seem to have a particularly strong effect on American artists. Clarification of the various modes of state-based and cultural suppression affecting political cartoonists in nineteenth-

century France and the contemporary United States may help viewers better understand similarities and differences in the tone and content of images from these eras.

Censorship in Nineteenth-Century France

The July Monarchy directly censored cartoonists by prohibiting disrespectful depictions of King Louis-Philippe. Politically charged images were considered dangerous because they had the capacity to affect the political opinion of illiterate citizens, who were numerous and potentially insurrectionary, and some legislators argued that images should be subject to stricter scrutiny than printed words.[1] For example, French legislator Claude-Joseph Jacquinot-Pampelune maintained that visual expression should be held to a different standard than written expression because

> caricatures, drawings, offer a means of
> scandal that is very easy to abuse and against
> which repressive [post-publication] mea
> sures can only be of very little help. As soon
> as they are exhibited in public, they are
> instantly viewed by thousands of spectators,
> and the scandal has taken place before the
> magistrate has had time to repress it.[2]

Prior to the July Revolution that brought Louis-Philippe to power in 1830, King Charles X focused on pre-publication methods of suppression and permitted prosecution of any critic of the government. On 25 July 1830, Charles X promulgated the "July Ordinances," under which printing plants were impounded, journals were seized, and presses were destroyed.[3] The July Revolution

was a response to these and other infringements of civil rights.

Immediately after the July Revolution, the new regime's constitutional charter abolished all press censorship.[4] Yet, in October 1830, a new law terminated *pre-publication* censorship, but granted the Interior Ministry great freedom to suppress images *post-publication*.[5] In November, press "attacks" against the king's "royal authority," images insulting the king's person, and comments on matters of succession to the throne or the government's legislative authority were all criminalized. A December 1830 law prohibited public posting of images with "political matters or themes" not explicitly approved by the government, and in April 1831 police seizure of offensive material was legalized, as was the arrest and prosecution of anyone involved in the publication of offensive images. The ministry censored thousands of caricatures and required the dramatic modification of images before publication, and, when laws were broken, police seized copies of the offending print or publication and arrested the artist, editor, and publisher.[6]

In July 1835, after an unsuccessful attempt on King Louis-Philippe's life, the government rushed to prevent any kind of incitement, and enacted some of the most repressive censorship laws in history. The September Laws of 1835 "rendered all forms of political satire impossible, owing to the severity of the penalties prescribed for their violation."[7] *La Caricature* was shuttered in August 1835. To remain viable, *Le Charivari* was forced to turn away from political satire, and instead focus on social satire that "figuratively thumbed its nose at the regime" without actually flouting the laws, as images from the 1830–1835 period had.[8]

Between 1830 and 1835, publishers such as Charles Philipon and artists such as Honoré Daumier resisted efforts to suppress their work, and generated boldly critical images. Resistance to censorship took the form of what Robert Justin Goldstein calls overt defiance or technical evasions: overt defiance included smuggling illegal journals, publishing caricatures anonymously, or failing to submit material to the Ministry before publication, while technical evasions included the use of blank space to denote censored images, or criticism disguised through literary and historical allusion.[9] Some of these allusions were blatant, and were caught by the king and his censors. For example, Daumier used Rabelais' *Gargantua* (page 34), a critique of the royal regime in Rabelais' own era, to draw unfavorable parallels to Louis-Philippe's "constitutional monarchy" and criticize the excesses of the king's official allowance. *Gargantua* seems designed to provoke a charge of *lèse-majesté* (high treason against the King) by employing an image of the king's face and body to criticize both the "royal body" and the "body politic."[10]

In compliance with the regulations, publisher Gabriel Aubert submitted *Gargantua* to the Interior Ministry in December 1831. The image was not approved for publication, but prints of the lithograph were sold at Aubert's shop; as a result, Daumier, Aubert, and printer Hippolyte Delaporte were charged with breaking the press laws, *lèse-majesté*, and "arousing hatred and contempt of the king's government." Daumier's trial centered on his artistic intent: did *Gargantua* literally depict the king or symbolically represent the government's budget? Daumier claimed that the print was an allegorical representation of the budget, because

the tiny ministers surrounding the central figure all looked exactly like Gargantua/Louis-Philippe, and this multiplicity was not literally possible. This was not a persuasive argument. Daumier, Aubert, and Delaporte were each sentenced to six months in prison and fined five hundred francs. When the three men appealed to the king, Aubert and Delaporte successfully reduced their sentences, but Daumier received no mercy because his "seditious crayon had traced the guilty image."[11]

Censorship in the United States

A close contemporary analogue to Daumier's *Gargantua* is Steve Brodner's *The Bushanos* (page 79), which likewise employs well-known fictional characters to criticize cronyism and corruption. *The Bushanos* compares President Bush and his advisors to fictional mobster Tony Soprano and his henchmen. By casting Vice President Cheney as Tony Soprano and President Bush as Christopher Moltisanti, Tony's feckless nephew, Brodner suggests that the vice president may truly be in charge of the executive branch of government. The inclusion of the president's mother and father implies that, like the Italian mafia, the Bush dynasty is a powerful "family," and this comparison insinuates that Bush and Soprano are both at the center of power structures reliant on tradition, connections, and ruthless, possibly illegal, dealings. Brodner's cartoon achieves everything visual satire should: it ruthlessly attacks its subjects, uses heightened depictions of fact to critique situations and behaviors, and employs references that the audience can quickly assimilate. *The Bushanos* is one of the most compelling and incisive images in this exhibition, but it humiliates differently than *Gargantua*. Brodner does not seek to degrade or excite disgust.

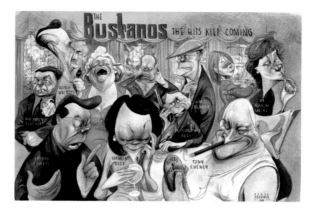

Steve Brodner, *The Bushanos*, 2003. Copyright Steve Brodner.

Instead, Brodner's subtlety is part of a much larger trend in American political commentary. Media critic Eric Alterman has suggested that attacks on the president are often tempered because American "presidents and the [American] media enjoy an informal agreement entitling every occupant of the Oval Office a certain amount of hero worship just for being there."[12] But, as cartoonist Pat Oliphant explains, "the job of the cartoonist is to be against the government, whatever it is."[13] The Supreme Court has repeatedly held that speech "against the government" enjoys the highest First Amendment protection because it is essential to the democratic process.[14] Today, there is "practically universal agreement" that the First Amendment is designed to "protect the free discussion of government affairs."[15] Further, the Court has affirmed that political caricature is a form of speech:

> Despite their sometimes caustic nature . . . graphic depictions and satirical cartoons have played a prominent role in public and political debate . . . Lincoln's tall, gangling posture, Teddy Roosevelt's glasses and teeth, and Franklin D. Roosevelt's jutting jaw and

cigarette holder have been memorialized by political cartoons with an effect that could not have been obtained by the photographer or the portrait artist. From the viewpoint of history it is clear that our political discourse would have been considerably poorer without them.[16]

However, after September 11, 2001, the "War on Terror" presented new challenges to free speech. Remarks made by members of the Bush Administration implied that political dissent could be interpreted as illegal.[17] Further, in October 2001, the Patriot Act outlawed "expert advice or assistance" and "material support for terrorist activities" and allowed the Federal Bureau of Investigation to seize "any tangible thing (including books, records, papers, documents and other items)" if taken "in connection with" a terror investigation.[18] The broad and confusing language of the Patriot Act suggested that political speech or writings might be considered "material support" or "expert advice" subject to seizure.[19]

The United States government cannot *directly* censor satirists through legislation such as the Patriot Act.[20] However, the First Amendment does *not* protect cartoonists from other sources of censorship, such as employers (i.e., newspapers), private persons (i.e., readers), or their own senses of decorum. Svetlana Mintcheva, a director of the National Coalition Against Censorship, believes that "a ubiquitous search for political 'balance' today often results in the suppression of even relatively mild critique," and that extralegal censorship often "masquerades as a search for political balance."[21] For instance, in response to comedian Bill Maher's caustic comments about the events of September 11, Press Secretary Ari Fleischer warned that all Americans "need to watch what they say, what they do."[22] Shortly thereafter, ABC declined to renew Maher's talk show.[23]

Media Ownership, Taste, and Self-Censorship

The power to suppress satire and political dissent is concentrated in the hands of a small group of private interests that may be influenced by the government's *preferences*. Today, the centralized structure of media corporations allows one company to alter the direction of multiple publications, and comedians and cartoonists may be simultaneously quelled by the decision of a central corporate parent. For example, when Continental Features (a media corporation that supplies comics to newspapers) decided to cancel distribution of Garry Trudeau's *Doonesbury* due to "numerous complaints," more than thirty-six publications were affected.[24] Changes to American media ownership legislation gave companies such as ABC unprecedented freedom to combine, allowing a spate of mergers that created monolithic corporations.[25] Between 1975 and 2007, two-thirds of the independent newspapers published in the United States folded.[26] These changes had a pronounced effect on the industry: today, six massive media corporations are in charge of most of the information we receive.[27] American cartoonist Clay Bennett believes that the lack of competition stifles political diversity because media concentration "encourages the one surviving newspaper to try to become all things to all people, to dread controversy rather than embrace it."[28] This lack of competition has a direct impact on cartoonists, because a newspaper is free to

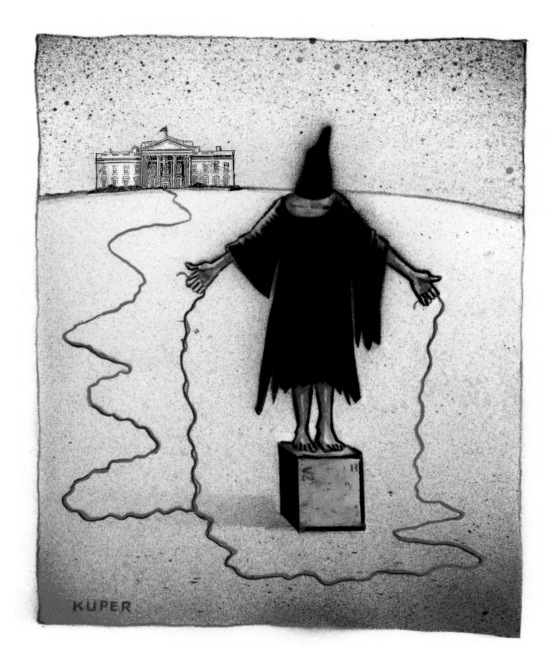

Peter Kuper, *Untitled*, 2004. Copyright Peter Kuper .

restrict a cartoonist's speech as a condition of his employment or freelance contract.

David Wallis, the author of a book on censored cartoons and the founder of the media syndicate Featurewell.com, believes that "the rise in media censorship coincides with the Bush administration's overt hostility towards the press." After September 11, there was a "tectonic shift in virtually every aspect of American politics and the media that covered it," and publications rapidly reduced the depth and breadth of their criticisms of the government.[29] According to cartoonist Peter Kuper, 2001 was "an extremely touchy time when everybody was terrified to say anything that didn't line up with the President."[30] Newspapers tended to refuse images that harshly criticized President Bush, fearing that these images might alienate readers or advertisers.[31] This was a reasonable expectation: surveys conducted in 2002 by the Freedom Forum's First Amendment Center demonstrated that American audiences disapproved of criticism of the president, the administration, the government, or the "War on Terror." Forty-nine percent of respondents believed "the First Amendment goes too far in the rights it guarantees," forty-two percent felt "the press in America has too much freedom to do what it wants," and forty percent "favored greater government restrictions on comedy routines that made light of or trivialized tragedies like the World Trade Center."[32] These statistics suggested that "the American public, the federal government, and state and local governments across the country [were] unwilling to tolerate dissent . . . including dissent that takes the form of political hyperbole, parody or sarcasm."[33]

American cartoonists did not back down, but controversial work was frequently censored by newspapers, and some cartoonists had to moderate their tone or leave their publications.[34] In 2001, Aaron McGruder's *Boondocks* was suspended by the *New York Daily News* for about six weeks, *Newsday* refused to run strips that were "September 11-inspired," and the *Dallas Morning News* isolated *Boondocks* in a separate section, far from less controversial comics.[35] In 2002, the *New York Times* website posted, then pulled, one of cartoonist Ted Rall's strips. Two years later, the website dropped Rall altogether, and Rall has suggested the *Times* cancelled his strip out of annoyance at reader objections.[36] In 2003, the *Chicago Tribune* refused to run two *Boondocks* strips that mocked President Bush's notorious "bring 'em on" comment.[37] Editor Dan Wycliff defended the *Tribune*'s decision as "editing," not "censorship," and suggested the refusal was merely a "matter of taste."[38] Dennis Draughton's "Bring 'Em On" cartoon for the *Scranton Times-Tribune* was also killed, because the *Times-Tribune* was receiving too many protest letters regarding Draughton's cartoons; his editor mandated "no more Bush cartoons," and Draughton resigned.[39] Also in 2003, Rick Cole of the *Trentonian* was told by his editor that he "might want to stay away from attacking Bush" if he wanted to publish any cartoons in the paper.[40] These are just a handful of examples that illustrate the American media's attitude towards controversial cartoons. Many other cartoonists were censored, and those who were able to publish cartoons critical of President Bush received a particularly high number of angry letters from readers.[41]

By contrast, the British cartoonists in this exhibition do not appear to be stifled by fears of controversy. Gerald Scarfe, staff cartoonist for

the *Sunday Times* of London, gives little thought to offending readers. According to Scarfe, "there's no political censorship [in the United Kingdom] at all. I'm often against what the leader page in the paper is saying . . . the idea of a cartoonist is like an opinion writer on a paper, you're there for your opinion, even if it is opposite. The great thing about [the United Kingdom], I guess, is that one can do that. It's very healthy. There are different points of view in the same newspaper."[42] In a telling comparison, Scarfe publish a cartoon, *How the Hell Did That Get Here?* (page 67), inspired by an iconic photograph from Abu Ghraib in the *Sunday Times*, but Peter Kuper's similar cartoon (page 39), inspired by the same photograph, was refused by the *New York Times*. In Scarfe's cartoon, the hooded man is centered atop President Bush's desk, like a large trophy brought to the Oval Office. Kuper's cartoon, a significantly subtler take on the president's possible connection to torture at Abu Ghraib, shows the same figure outside the White House, and suggests that someone inside is holding the end of the wires attached to the figure's hands. The image was still too potent for the *New York Times*. According to Kuper, the "direct connection of the wire going to the White House didn't fly. They want to be subtle enough that they don't get fingers pointed at [them]."[43]

The cumulative effect of repeated censorship is *self*-censorship. Aaron McGruder finds that "part of the creative process [is] me trying to walk that line and say the things I want to say without taking it too far and doing stuff that you're just not allowed to do in the newspapers."[44] Cartoonist Paul Szep finds that he "can't get things printed on a regular basis" when he does not self-censor.[45] Today, cartoonists must be aware of their

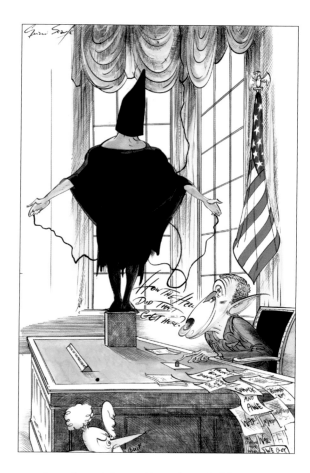

Gerald Scarfe, *How the Hell Did That Get Here?* 2004. Copyright Gerald Scarfe.

employer's and the audience's probable response, and be willing to moderate their commentary— or risk losing their jobs.

The Compliment of Suppression

The July Monarchy is known as a "golden age of caricature," because the images from this period remain some of the most stirring political artworks ever created. It must be remembered that artists working in this period responded to specific pressure from a single source—the king and his

censors. Philipon and his journals were not conceived as a form of resistance to this pressure, but the journals' powerful visual messages reached beyond the lines of socioeconomic class and literacy, unified a diverse group of readers, and served as a primary voice of dissent in a more generalized backlash against the authoritarian monarch.

By contrast, contemporary artists must respond to pressure from many sources, including the political establishment, their employers, and their audiences. Contemporary caricaturists are continually asked to present a "balanced" view of the president and his administration, a demand that is often at odds with the purpose and character of satire. The images in this exhibition are a testament to the creativity and commitment of contemporary American and British cartoonists who have worked against mixed demands for moderation, captured the public imagination, and successfully reestablished a taste for biting, direct satire.

"Humor is considered subversive by the powers that be, who often pay it the compliment of suppression."[46] In a democratic society, we are "the powers that be." As readers, viewers, and consumers, when we quietly accept a decline in substantive criticism, we act as censors. If we hope to fulfill the promise of the First Amendment, we must ask to be exposed to different viewpoints, even those we oppose, and we must support those who create bold political artwork in times of flux and uncertainty.

NOTES

1. Robert Justin Goldstein, "The Debate Over the Censorship of Caricature in Nineteenth-Century France," *Art Journal* 48 (Spring 1989), p. 9; Goldstein, "Fighting French Censorship, 1815–1881," *The French Review* 71 (April 1998), p. 785.

2. Goldstein, "Debate," p. 9.

3. Stuart Kadison, "The Politics of Censorship," in *The Charged Image: French Lithographic Caricature 1816–1848* (Santa Barbara: Santa Barbara Museum of Art, 1989), p. 25.

4. Goldstein, "Fighting French Censorship," 788–91.

5. David S. Kerr, *Caricature and French Political Culture, 1830–1848* (Oxford: Oxford University Press, 2000), pp. 14, 19, 121.

6. Offenders were subject to up to five years in prison and a six thousand franc fine. Robert Justin Goldstein, *Censorship of Political Caricature in Nineteenth-Century France* (Kent, OH: Kent State University Press, 1989), pp. 122–23.

7. Kadison, "The Politics of Censorship," p. 27.

8. Beatrice Farwell, "The Charged Image," in *The Charged Image: French Lithographic Caricature 1816–1848* (Santa Barbara: Santa Barbara Museum of Art, 1989), p. 12.

9. Goldstein, "Fighting French Censorship," pp. 787–91.

10. Elizabeth C. Childs, "Big Trouble: Daumier, Gargantua, and the Censorship of Political Caricature," *Art Journal* 51 (Spring 1992), pp. 26, 31.

11. Over the course of his career, twenty-four of Daumier's lithographs were censored, but he was prosecuted only for *Gargantua*. See Childs, "Big Trouble," pp. 27, 34, 35. For the reasoning behind Daumier's sentence, Childs quotes Archives Nationales, Paris, BB21 373 (no. 4172–S8).

12. See Eric Alterman, *What Liberal Media?* (New York: Basic Books, 2003), p. 193.

13. David Wallis (ed.), *Killed Cartoons* (New York: W. W. Norton, 2007), quoting Oliphant, p. 11.

14. There are categorical exceptions to First Amendment protections, including incitement to illegal activity or imminent violence (*Brandenburg v Ohio*, 395 U.S. 444 [1969]); defamation and libel (*Gertz v. Robert Welch*, 418 U.S. 323 [1974]; *New York Times v. Sullivan*, 376 U.S. 254 [1964]); obscenity (*Miller v. California*, 413 U.S. 15 [1973]); and threats and intimidation (*Chaplinsky v. New Hampshire*, 315 U.S. 568 [1942]).

15. *Burson v. Freeman*, 504 U.S. 191, 196 (1992).

16. *Hustler v. Falwell*, 485 U.S. 46, 54–55 (1988).

17. Chris Lamb, *Drawn to Extremes: The Use and Abuse of Editorial Cartoons* (New York: Columbia University Press, 2004), p. 219. See also Nancy Kranich, "The Impact

of the USA PATRIOT Act on Free Expression," *The Free Expression Policy Project*, available at http://www.fepproject.org/commentaries/patriotact.html

18. Lamb, *Drawn to Extremes*, p. 219.

19. See Stewart A. Baker and John Kavanaugh (eds.), *Patriot Debates: Experts Debate the USA Patriot Act* (American Bar Association, 2005).

20. The Patriot Act is not singular. Historically, political dissent has been intermittently curtailed in response to pressures on national security. The 1798 Alien and Sedition Acts barred any "false, scandalous and malicious writing or writings" concerning the president or the government; the Espionage Act of 1917 and Sedition Act of 1918 forbade mailing any matter (including newspapers) advocating treason, insurrection, or forcible resistance to U.S. laws, and allowed the postmaster general to intercept "periodicals that interfered with the war effort"; and the Alien Registration Act of 1940 (the Smith Act) made it a crime to "advocate, abet, advise, or teach the duty, necessity, desirability, or propriety of overthrowing or destroying any government in the United States by force or violence." All of these acts eventually expired, were amended, or were repealed. However, the Antiterrorism and Effective Death Penalty Act of 1996 "material support" to foreign terrorist organizations and the Patriot Act are still in place.

21. Svetlana Mintcheva, "The Censor Within," in *Censoring Culture: Contemporary Threats to Free Expression* (New York: New Press, 2006) pp. 299–300.

22. Statement made 26 September 2001. The full text of the press briefing is available at http://georgewbush-whitehouse.archives.gov/news/releases/2001/09/20010926-5.html#BillMaher-Comments

23. "Maher cancelled, Kimmel lands slot at ABC," CNN.com, 14 May 2002, available at http://archives.cnn.com/2002/SHOWBIZ/TV/05/14/television.kimmel/

24. Continental Features did survey its clients before cancelling *Doonesbury*. Wallis, *Killed Cartoons*, p. 14.

25. See Adam Candeub, *Media Ownership Regulation, the First Amendment, and Democracy's Future*, 41 U.C. Davis L. Rev. 1547.

26. "Media Consolidation," *FreePress.net*, available at http://www.freepress.net/policy/ownership/consolidation

27. Candeub, *Media Ownership Regulation*, 1555, 1549.

28. Wallis, quoting Clay Bennett, p. 12.

29. Wallis, *Killed Cartoons*, p. 18.

30. Wallis, *Killed Cartoons*, quoting Kuper, p. 17.

31. See Wallis, *Killed Cartoons*, pp. 16–22; Lamb, *Drawn to Extremes*, pp. 193–224; and Eric Alterman, *What Liberal Media?* (New York: Basic Books, 2003), pp. 268–92.

32. Gilbert, p. 854.

33. Ibid., p. 853.

34. "Controversial Comics Raise Serious Dilemmas," *Boston Globe*, 22 October 2003, E1.

35. Stephen Lemons, "Aaron McGruder, Creator of 'The Boondocks,'" *Salon.com*, available at http://dir.salon.com/story/people/feature/2001/12/07/mcgruder/print.html

36. Wallis, *Killed Cartoons*, p. 12.

37. Dan Wycliff, "A Matter of Taste: When the Funnies Aren't So Funny," *Chicago Tribune*, 23 July 2003, p. 27. See also Jarrett Murphy, "Bring 'Em On' Fetches Trouble," CBSNews.com, 3 July 2003, available at http://www.cbsnews.com/stories/2003/07/03/iraq/main561567.shtml

38. Wycliff, "A Matter of Taste," p. 27.

39. It is important to understand that Draughton was not necessarily moving on to another position. This is a very real concern: between 1980 and 2004, the number of editorial cartoonists employed by U.S. newspapers declined by half. Wallis, *Killed Cartoons*, pp. 16, 200.

40. Wallis, *Killed Cartoons*, quoting Cole, p. 188.

41. See Wallis, *Killed Cartoons*, and Lamb, *Drawn to Extremes*, for numerous examples.

42. "London Conversation: Gerald Scarfe," *London Conversation*, 27 February 2007, available at http://londonconversation.blogspot.com/2007/02/gerald-scarfe.html

43. Wallis, *Killed Cartoons*, quoting Kuper, p. 200.

44 Lemons, "Aaron McGruder."

45. Wallis, *Killed Cartoons*, quoting Szep, p. 17.

46. Gerald Gardner, *The Mocking of the President: A History of Campaign Humor from Ike to Ronnie* (Detroit, MI: Wayne State University Press, 1988), p. 12.

Chez Aubert, galerie véro dodat.

L. de Bénard.

Voici Messieurs, ce que nous avons l'honneur d'exposer journellement.

Si vous êtes contens et satisfaits faites en part à vos amis et connaissances, On ne paye qu'en s'abonnant et il faudrait vraiment ne pas avoir 13 f. dans sa poche pour se priver de voir cette magnifique collection qui fait tous les jours l'amusement du Roi et de son Auguste famille.

zin, zin, zin, baound! beund! baound! baound!!

CARICATURE SERVED AS a potent political weapon in the months surrounding the fall of King Charles X, who was chased from power in France's July revolution of 1830. The leering, lantern-jawed monarch, accused of a reactionary bid to jettison the foundations of constitutional rule, was soon replaced in the public imagination by a new object of scorn: Louis-Philippe, spirited into office by a small group of economic and political leaders. Caricaturists played a significant role in the opposition's campaign against the new king, whom they accused of betraying initial promises to promote civil liberties and social justice. The comic journals *La Caricature* and *Le Charivari*, edited by Charles Philipon, rapidly devised a devastatingly effective visual vocabulary to undermine the king's dignity and attack his ideological retreat. In November 1831, Philipon's transformation of Louis-Philippe's heavily jowled, bewhiskered head into the form of a pear inspired a deluge of mockery, as caricaturists exploited the visual pun as a spur to comic inventiveness and a mask for coruscating critique. The figure of the king himself, presented as a smugly prosaic bourgeois, was often directly targeted in caricature. Though the monarch's face is often averted, his distinctive coiffure and corpulent physique make him instantly recognizable. Cartoonists' use of parody, in which Old Master paintings or more recent successes from the Paris Salon are adapted for commentary on topical events, draws upon a ploy that had become popular in eighteenth-century caricature.

Caricaturing Louis-Philippe

Plates

Charles Joseph Traviès de Villiers, *Voici, Messieurs, ce que nous avons l'honneur d'exposer journellement. Si vous êtes contens et satisfaits faites en part à vos amis et connaissances. On ne paye qu'en s'abonnant et il faudrait vraiment ne pas avoir 13f dans sa poche pour se priver de voir cette magnifique collection qui fait tous les jours l'amusement du Roi et de son Auguste famille. zin . . . baound!* (Here, gentlemen, is what we have the honor of showing every day. If you are pleased and satisfied, take part in it with your friends and acquaintances; you don't have to pay until you subscribe and you need to have only 13 francs in your pocket to be privileged to see this magnificent collection, which amuses the king, as well as his august family every day). *La Caricature*, No. 174, pl. 366 and 367, 6 March 1834. Mount Holyoke College Art Museum, South Hadley, Massachusetts.

Charles Philipon, *Le Replâtrage* (Replastering). *La Caricature*, No. 35, pl. 70, 30 June 1831. Mount Holyoke College Art Museum, South Hadley, Massachusetts.

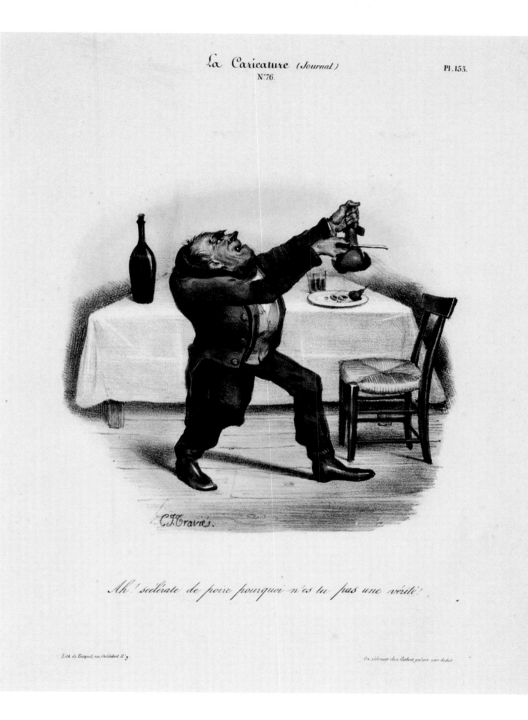

Charles Joseph Traviès de Villiers, *Ah! Scélérate de poire pourquoi n'es tu pas une vérité!* (Ah! Villainous pear, why are you not a truth!). *La Caricature*, No. 76, pl. 153, 12 April 1832. Mount Holyoke College Art Museum, South Hadley, Massachusetts.

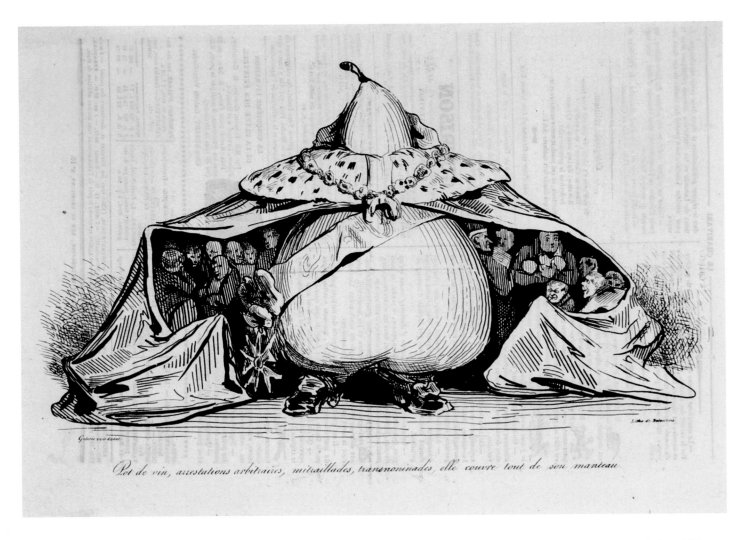

Honoré-Victorin Daumier, *Pot de vin . . . arrestations arbitraires, mitraillades, transnoninades, elle couvre tout de son manteau* (Bribes, high-handed arrests, volleys of grape-shot, murderers of rue Transnonain, she covers them all with her robe). *Le Charivari*, 7 September 1834. Mount Holyoke College Art Museum, South Hadley, Massachusetts.

la Caricature *(Journal)* N° 129.

Pl. 267

Auguste Desperret, *Untitled (Louis Philippe en geolier à cheval sur trois cages, "Ste. Pélagie," "La Force," "Blaye"* [Louis Philippe as a jailer straddling three cages, St. Pélagie, La Force, Blaye]). *La Caricature*, No. 129, pl. 267, 25 April 1833. Mount Holyoke College Art Museum, South Hadley, Massachusetts.

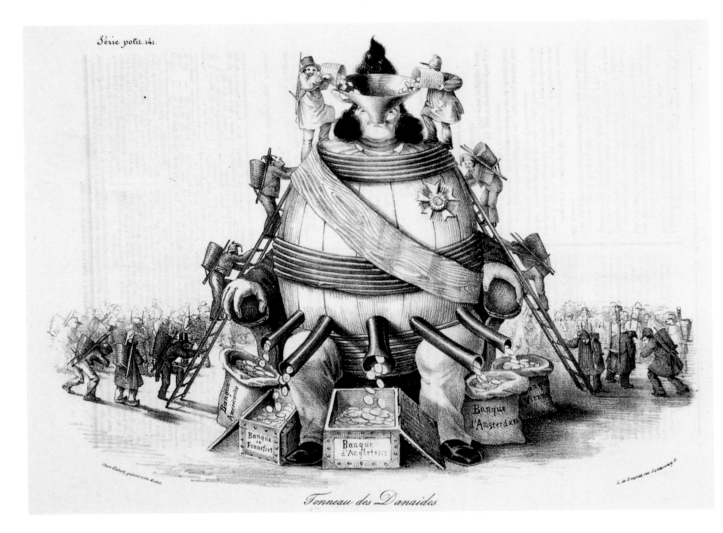

Auguste Desperret, *Tonneau des Danaïdes* (The Danaides' Barrel), *Le Charivari*, Série polit. 141, 18 December 1833. Mount Holyoke College Art Museum, South Hadley, Massachusetts.

Honoré-Victorin Daumier, *Count Auguste-Hilarion de Kératry*, 1832–35. Jane Voorhees Zimmerli Art Museum, Rutgers, The State University of New Jersey. Acquired in honor of Barbara Voorhees, 2001.0381. Photo by Jack Abraham.

J. J. Grandville, *Le Ministère attaqué de choléra-morbus* (The ministry attacked by cholera morbus), *La Caricature*, No. 40, pl. 79, 4 August 1831. Mount Holyoke College Art Museum, South Hadley, Massachusetts.

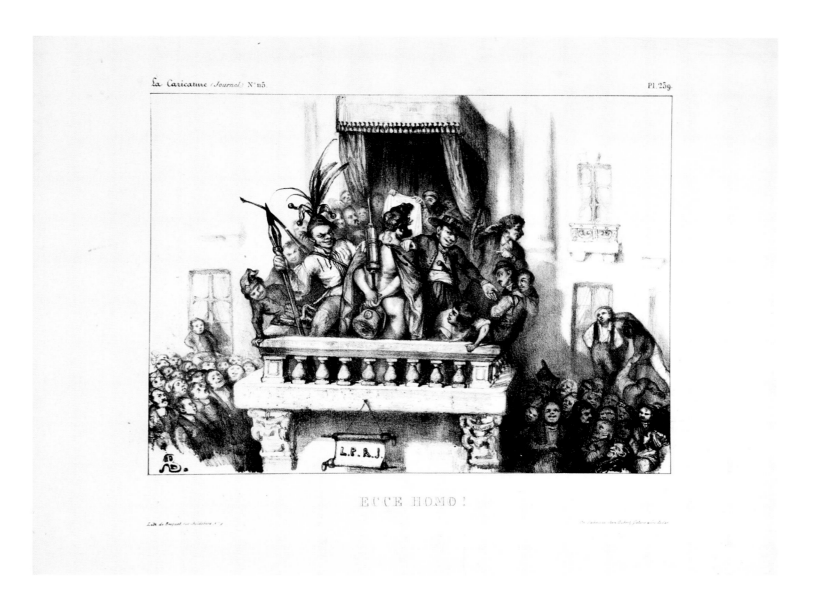

ECCE HOMO!

Auguste Bouquet, *Ecce homo!* (Behold the Man!). *La Caricature*, No. 115, pl. 239, 17 January 1833. Mount Holyoke College Art Museum, South Hadley, Massachusetts.

Honoré-Victorin Daumier, *Le cauchemar* (The nightmare). *La Caricature*, No. 69, pl. 139, 23 February 1832. Mount Holyoke College Art Museum, South Hadley, Massachusetts.

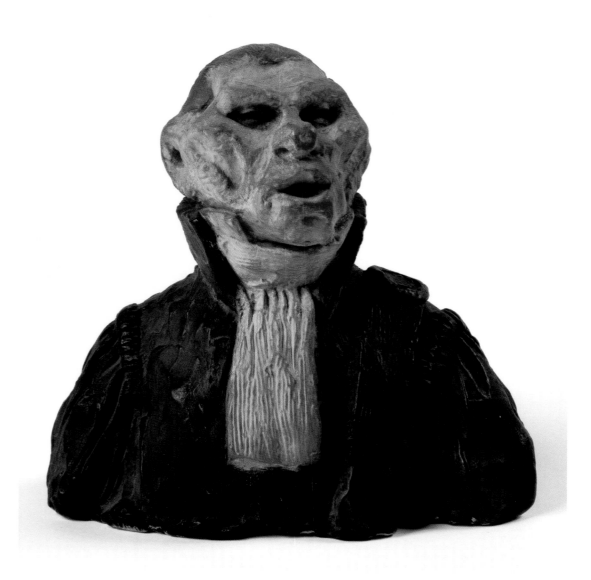

Honoré-Victorin Daumier,
*André-Marie-Jean-Jacques Dupin,
called Dupin aîné,* 1832–35. Jane
Voorhees Zimmerli Art Museum,
Rutgers, The State University of
New Jersey. Acquired in honor
of Barbara Voorhees, 2001.0407.
Photo by Jack Abraham.

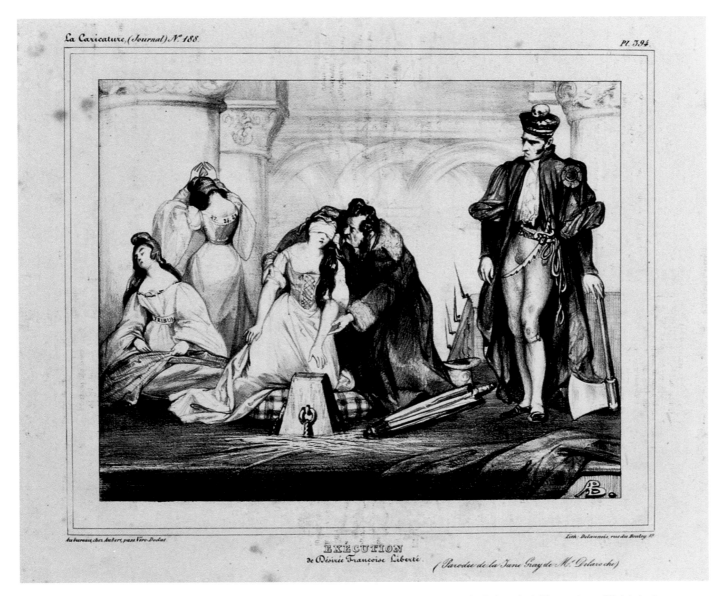

Pl. 394.

EXÉCUTION
de Désirée Françoise Liberté

(Parodie de la Jane Gray de M.ᵉ Delaroche)

Auguste Bouquet, *Exécution de Désirée Françoise Liberté (Parodie de la Jane Grey de Mr. Delaroche)* (Execution of Désirée Fran-çoise Liberty [Parody of Jane Grey by Mr. Delaroche]). *La Caricature*, No. 188, pl. 394, 13 June 1834. Mount Holyoke College Art Museum, South Hadley, Massachusetts.

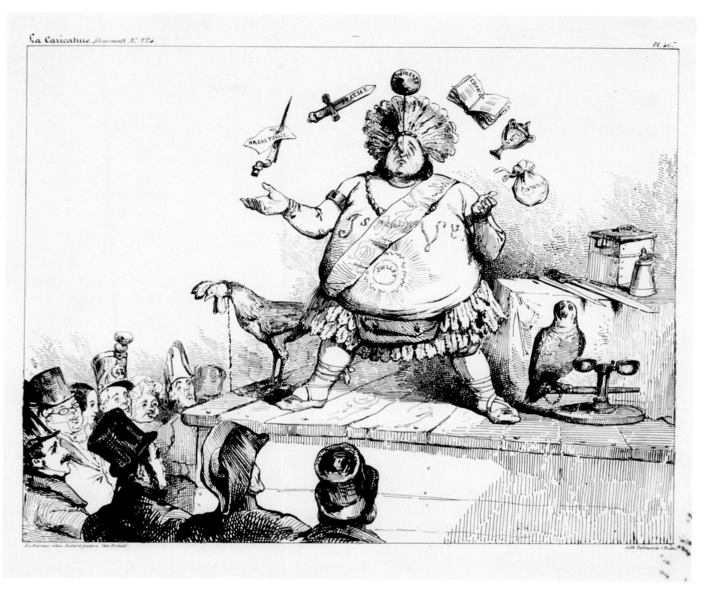

J. J. Grandville, Eugene-Hippolyte Forest, *Untitled (Le Jongleur, sauteur, banquiste et prestidigitateur* [The juggler, unreliable fellow, charlatan, and magician]). *La Caricature*, No. 224, pl. 467, 5 May 1835. Mount Holyoke College Art Museum, South Hadley, Massachusetts.

CARICATURISTS TODAY DRAW UPON traditions extending back to the nineteenth century and beyond, though they have a significantly different range of cultural references at their disposal in the ways they can shape the character and reputation of public figures for satirical ends. Metaphor, analogy, and personification continue to be used to endow political personalities with readily legible qualities that serve to define their personal actions and political beliefs. President Clinton's sexual misadventures and pursuit of campaign contributions helped to project an image of freewheeling irresponsibility rendered visually in terms of a shambling, loose-limbed physique. President Bush's dramatically varying political fortunes and contested reputation produced a complex web of representations. Variously personified as cowboy, crusader or chimp, infantile midget or imperious monarch, George Bush came to stand for much more than himself as an individual political actor, symbolizing a particular domestic ideology (freedom, religiosity, laissez-faire capitalism) and, beyond the nation's borders, a particular perception of America's place in the world. In pursuing these themes, caricaturists in the United States and the United Kingdom subjected the president to multiple metaphors and metamorphoses, drawing on cultural references far broader and more diverse than were available to previous generations of cartoonists. Cable, MTV, the internet, advertising imagery, news photography, and the movies supplement more traditional sources of inspiration for caricaturists who themselves increasingly look to new media as an outlet for their satirical commentary on current events.

Caricature and the Contemporary Presidency

Plates

Kevin KAL Kallaugher, *Clinton Temptations,* 1998. Copyright Kevin KAL Kallaugher.

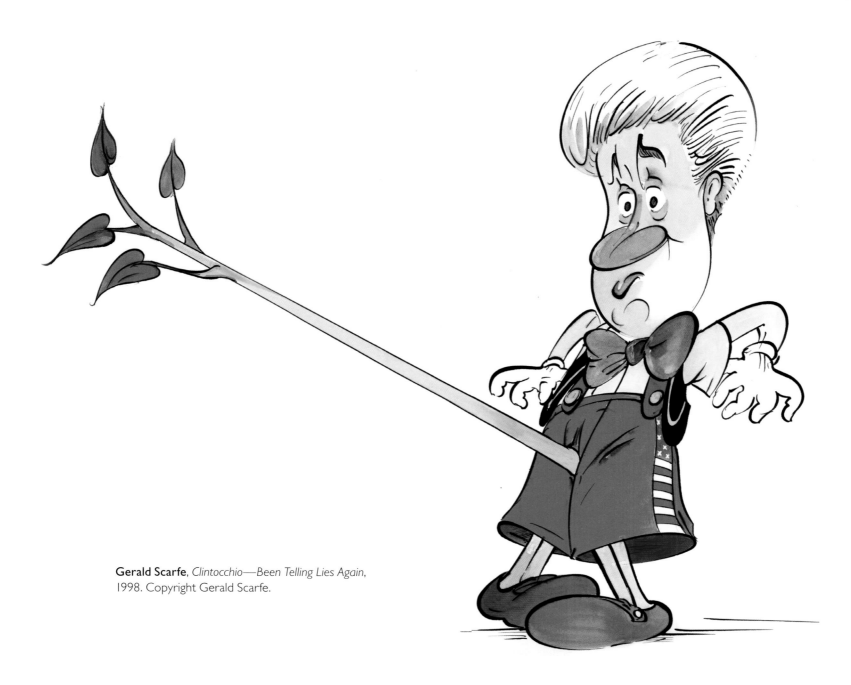

Gerald Scarfe, *Clintocchio—Been Telling Lies Again*, 1998. Copyright Gerald Scarfe.

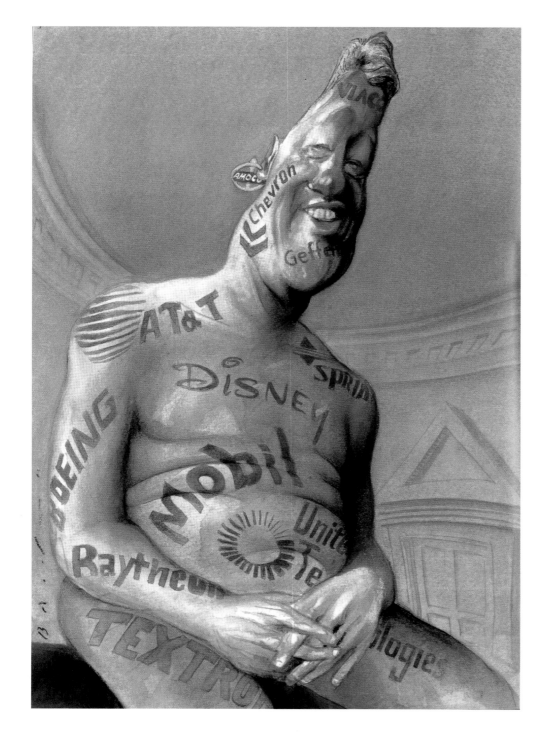

Steve Brodner, *Clinton Illustrated*, 1996. Copyright Steve Brodner.

Mr. Fish (Dwayne Booth), *George Bush in the Oval Office Watching Karl Rove Leave the White House*, 2007. Courtesy of Mr. Fish.

Kevin KAL Kallaugher, *Florida*, 2000. Copyright Kevin KAL Kallaugher.

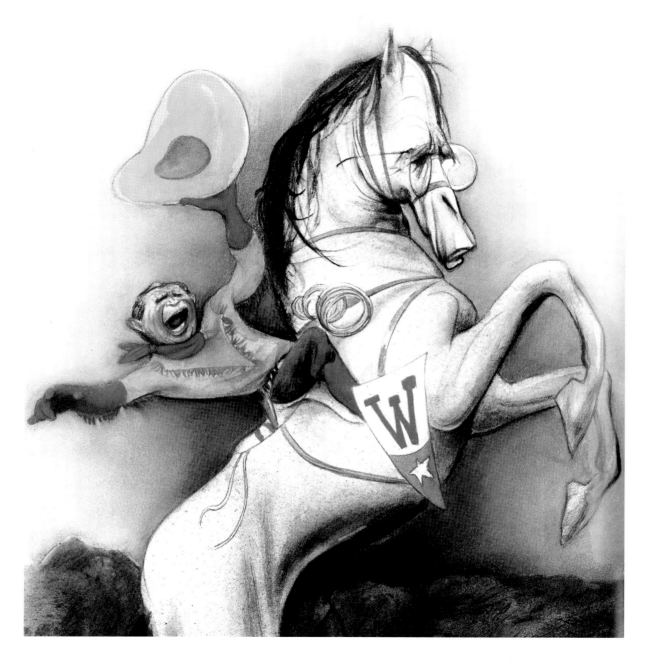

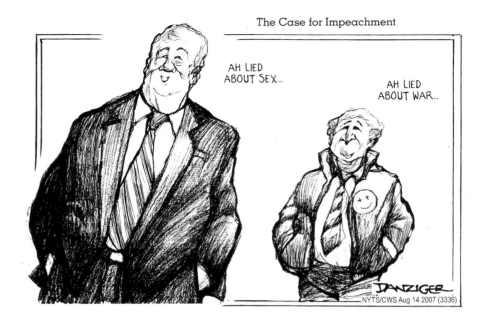

Jeff Danziger, *The Case for Impeachment*, 2007. Copyright Jeff Danziger/New York Times Syndicate.

Gary Varvel, *Which Suit Most Offends Democrats?* 2003. Copyright 2003 Creators Syndicate.

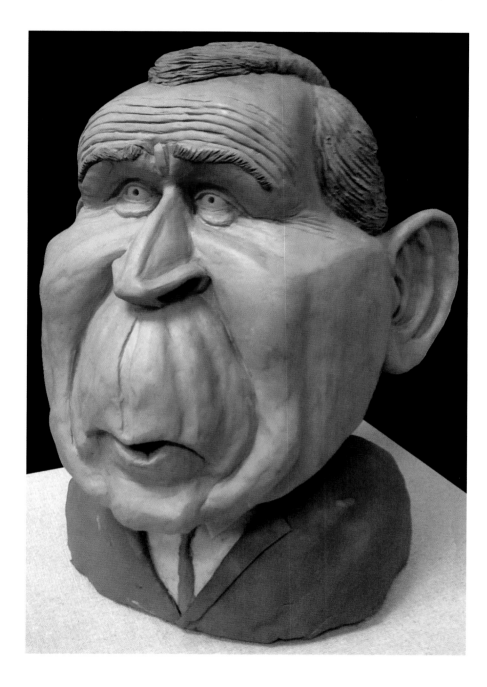

Kevin KAL Kallaugher, *Dubya or Bust,* 2006. Courtesy of Kevin KAL Kallaugher.

Doonesbury

Garry Trudeau, Doonesbury Daily Strip, 6 August 2001. Copyright Garry Trudeau.

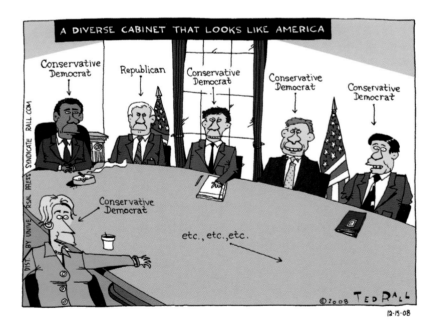

Ted Rall, *A Cabinet that Looks Like America,* 2000. Copyright Ted Rall/Universal Press Syndicate.

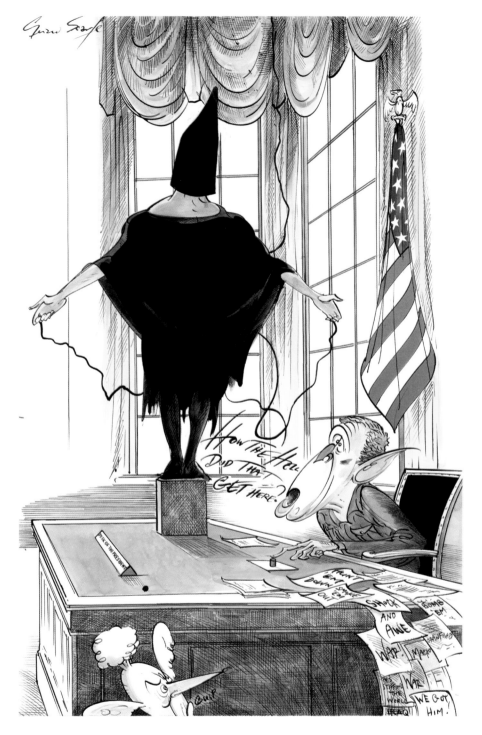

Gerald Scarfe, *How the Hell Did That Get Here?* 2004. Copyright Gerald Scarfe.

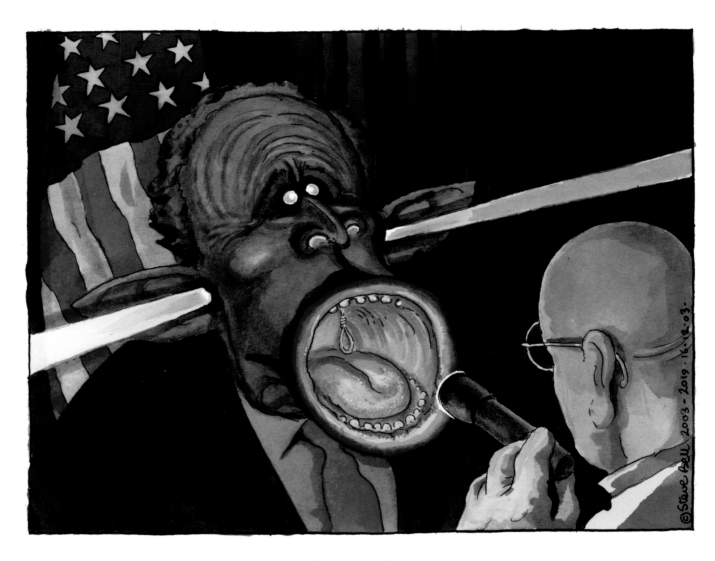

Steve Bell, *Bush Throat Job*, 2003. Copyright 2003 Steve Bell. All rights reserved.

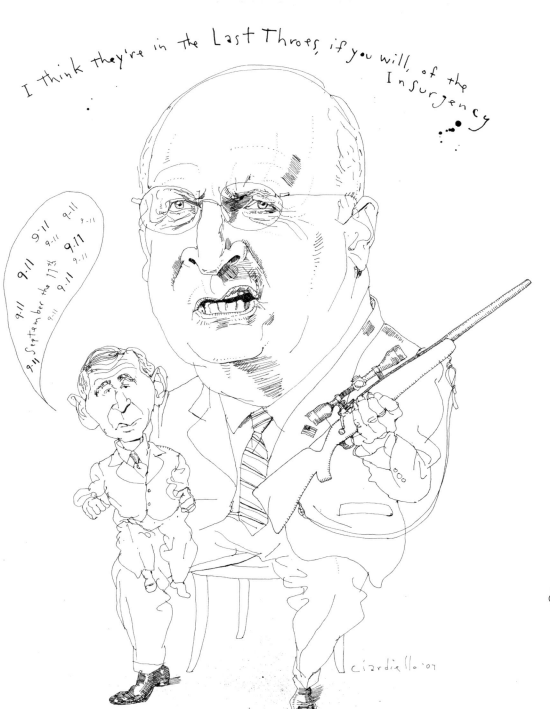

Joe Ciardiello, *Dick and Dummy, 2007*.
Copyright 2008 Joe Ciardiello.

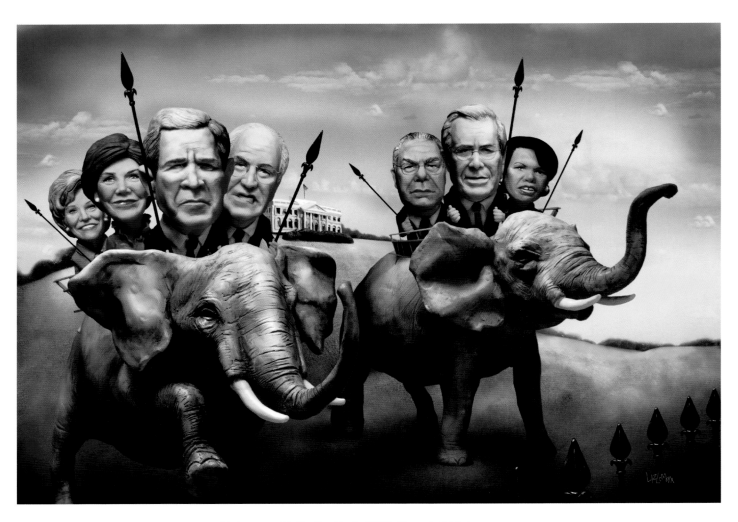

Liz Lomax, *Oh No You Don't,* 2004. Copyright Liz Lomax.

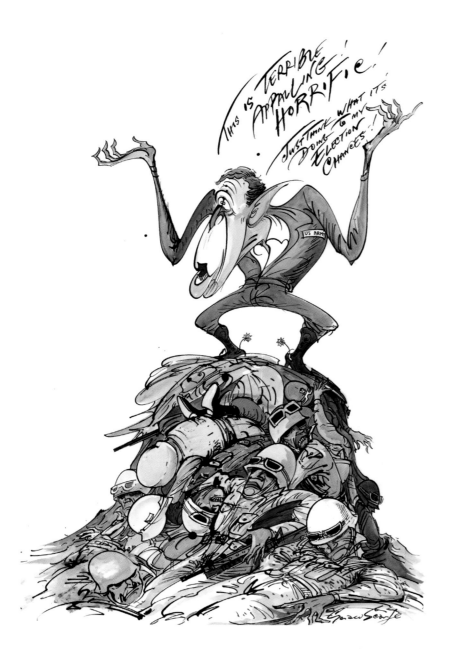

Gerald Scarfe, *My Election Chances*, 2004.
Copyright Gerald Scarfe.

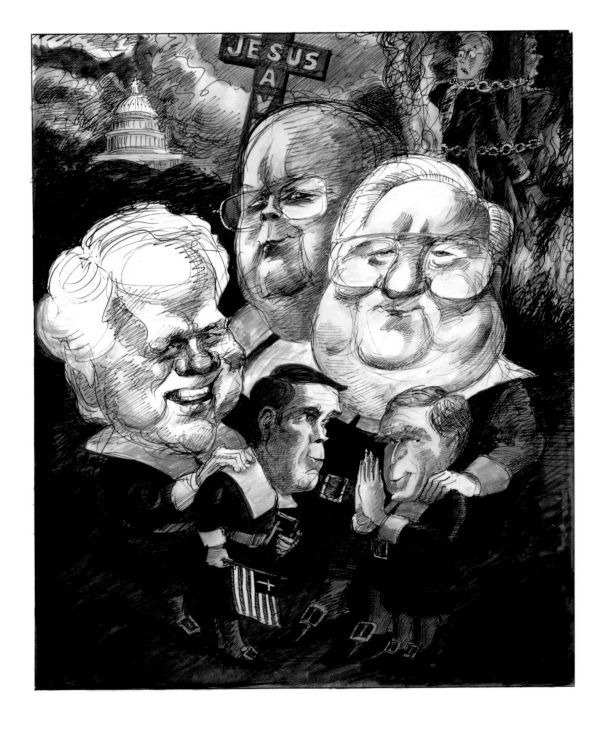

Edward Sorel, *In Clods We Trust*, 2007. Copyright Edward Sorel.

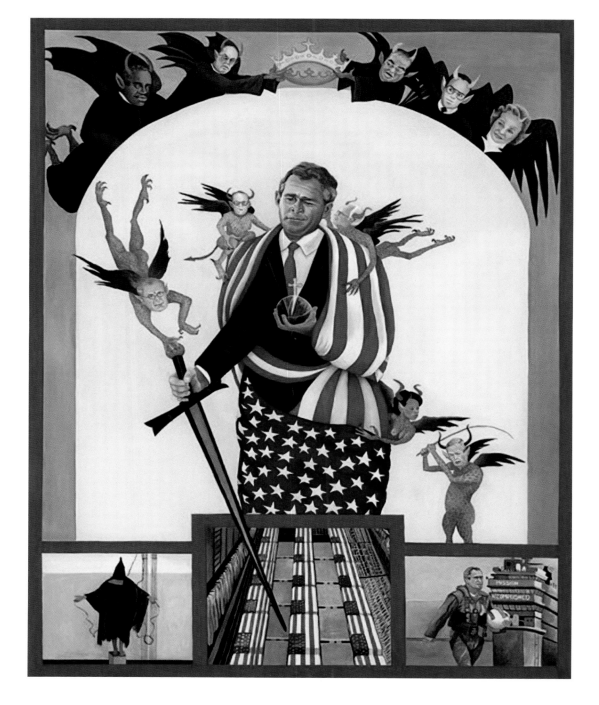

Lynn Randolph, *The Coronation of Saint George*, 2004. Copyright Lynn Randolph.

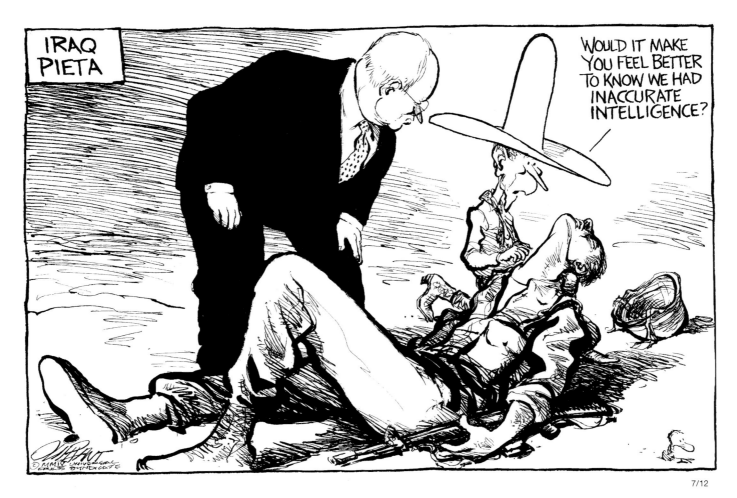

Pat Oliphant, *Iraq Pietà*, 2004. Copyright 2004 Patrick Oliphant. Courtesy of Susan Conway Gallery, Santa Fe, New Mexico, and Washington, D.C.

Peter Kuper, *Ceci n'est pas une comic,* 2008. Copyright Peter Kuper.

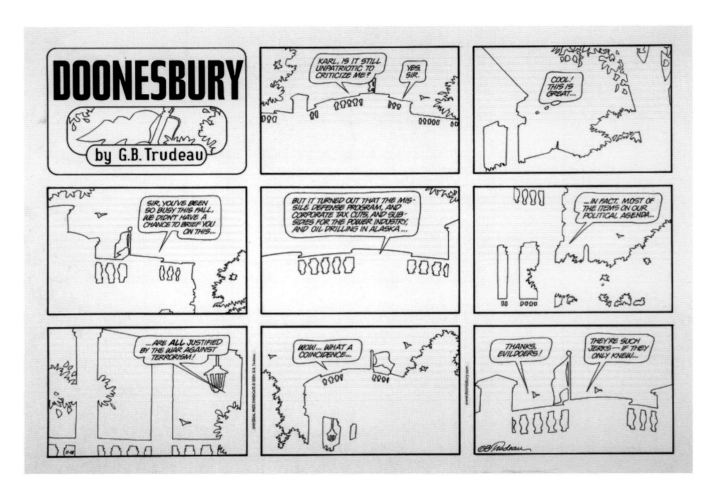

Garry Trudeau, Doonesbury Sunday Strip, 18 November 2001. Copyright Garry Trudeau.

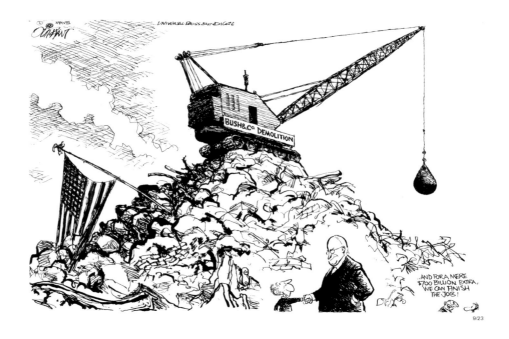

Pat Oliphant, *Bush & Co. Demolition*, 2008. Copyright 2004 Patrick Oliphant. Courtesy of Susan Conway Gallery, Santa Fe, New Mexico, and Washington, D.C.

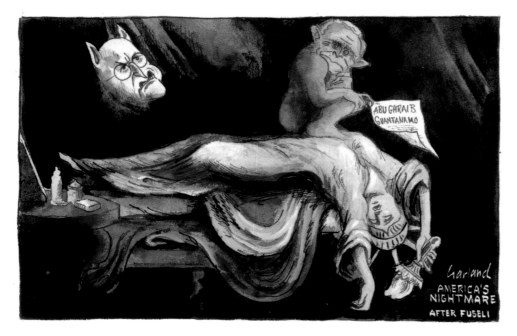

Nicholas Garland, *America's Nightmare—after Fuseli*, 2006. Copyright Nicholas Garland/Daily Telegraph (UK).

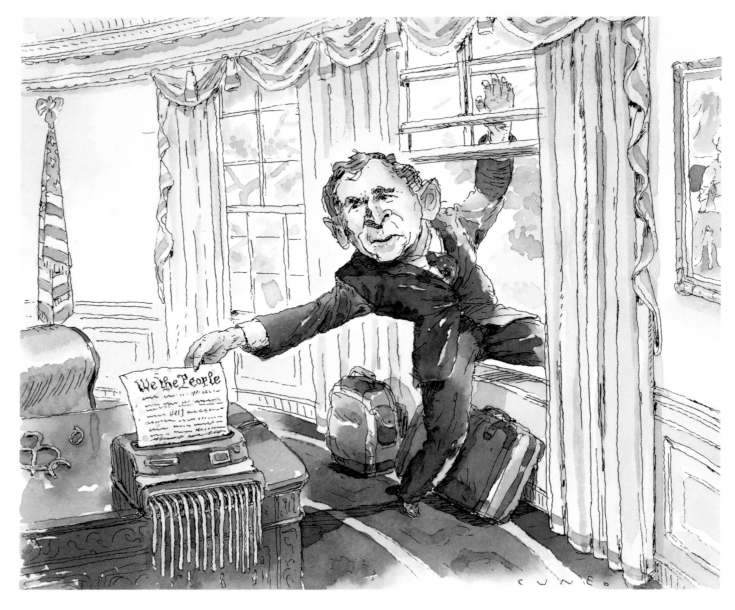

John Cuneo, *Bush's Final F. U.,* 2008. Copyright John Cuneo.

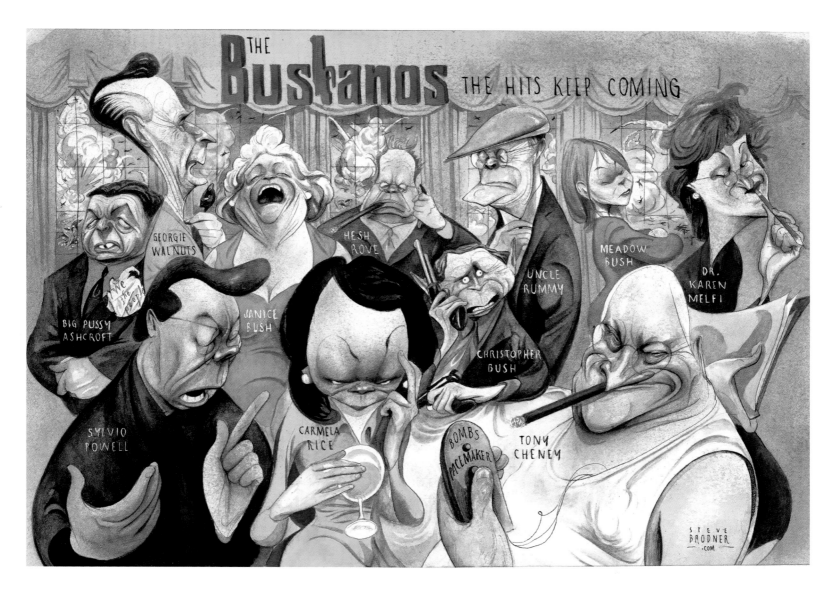

Steve Brodner, *The Bushanos*, 2003. Copyright Steve Brodner.

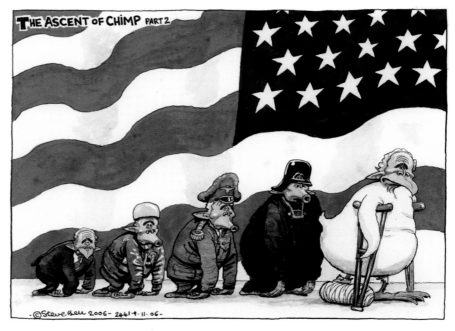

Steve Bell, *The Ascent of the Chimp Part 2*, 2006. Courtesy of Simon M. Powell.

Martin Rowson, *Wolf, Wolf*, 2007. Courtesy of Martin Rowson and Guardian News and Media Archive, United Kingdom.

THIS MODERN WORLD

by TOM TOMORROW

A FAREWELL SALUTE...

©TOM TOMORROW ... FOR THE LONG-AWAITED WEEK OF 1-20-09

Tom Tomorrow, *Farewell to Bush (Shower of Shoes)*, 2009. Copyright Tom Tomorrow.

Lines of Attack: Conflicts in Caricature | Exhibition Checklist

Caricaturing Louis-Philippe

Anonymous, French, 19th Century. *Mayeux devenu Garde des Lots* (Monsieur Mayeux as guard), ca. 1830. Lithograph, 9½ × 7⅝ inches. Lent by the Metropolitan Museum of Art, The Elisha Whittelsey Collection, The Elisha Whittelsey Fund, 1958, 58.512.60.

Anonymous, French, 19th Century. *Cette canaille de peuple fait quelquefois des plaisanteries de bien mauvais ton!* (The rabble sometimes makes jokes in very poor taste!) (Charles X), ca. 1830. Lithograph, 7⅝ × 11⅛ inches. Lent by the Metropolitan Museum of Art, The Elisha Whittelsey Collection, The Elisha Whittelsey Fund, 1958, 58.512.41.

Anonymous, French, 19th Century. *Voulez-vous faire peur? Montrez les dents* (Do you want to scare them? Show your teeth) (Charles X), c. 1830. Lithograph, 9⅞ × 11⅞ inches. Lent by the Metropolitan Museum of Art, The Elisha Whittelsey Collection, The Elisha Whittelsey Fund, 1958, 58.512.30.

Anonymous, French, 19th Century. *Pour la troisième et dernière fois c'est bien vu, bien entendu. Personne n'en veut plus . . . Enfoncé!* (For the third and final time, just understand. Everybody has had enough!) (Charles X), ca. 1830. Lithograph, 10 × 7⅝ inches. Lent by the Metropolitan Museum of Art, The Elisha Whittelsey Collection, The Elisha Whittelsey Fund, 1958, 58.512.31.

Anonymous, French, 19th Century. *Les Temps sont durs* (Times are hard), 1833. Lithograph, 9⁵⁄₁₆ × 10⅞ inches. *Le Charivari*, Série polit. 131, 31 October 1833. Mount Holyoke College Art Museum, South Hadley, Massachusetts. Gift of Mr. and Mrs. Howard P. Vincent (Mary Wilson Smith, Class of 1926), 1988.20.6.

Anonymous, French, 19th Century. *Un Pauvre Père de famille . . . Qui n'a que quelques millions de revenus* (A poor family father . . . who has only a few million as income), 1833. Lithograph, 11⅜ × 9 inches. *Le Charivari*, Série polit. 129, 11 November 1833. Mount Holyoke College Art Museum, South Hadley, Massachusetts. Gift of Mr. and Mrs. Howard P. Vincent (Mary Wilson Smith, Class of 1926), 1988.20.17.

Anonymous, French, 19th Century. *Hôtel Lafitte*, 1833. Lithograph, 8⅝ × 11¼ inches. *Le Charivari*, Série polit. 139, 28 December 1833. Mount Holyoke College Art Museum, South Hadley, Massachusetts. Gift of Mr. and Mrs. Howard P. Vincent (Mary Wilson Smith, Class of 1926), 1988.20.13.

Auguste Bouquet, French, 1800–1846. *Pauvre liberté, qu'elle queue!!* (Poor liberty, what a tail!), 1831. Lithograph, 9¼ × 9⁵⁄₁₆ inches. *La Caricature*, No. 61, pl. 124, 29 December 1831. Mount Holyoke College Art Museum, South Hadley, Massachusetts. Gift of Mr. and Mrs. Howard P. Vincent (Mary Wilson Smith, Class of 1926), 1991.10.2.

Auguste Bouquet, French, 1800–1846. *A quatorze millions! . . . à quatorze millions! . . . c'est pour rien . . . personne / ne dit mot? . . . quatorze millions!! quatorze millions! à quatorze millions! / Adjugé!* (Fourteen million! . . . fourteen million! . . . it's a very low price . . . no one is going to say anything? . . . fourteen million!! fourteen million! fourteen million! Going, going, gone!), 1832. Lithograph, 11¼ × 8⅛ inches. *La Caricature*, No. 64, pl. 130, 19 January 1832. Mount Holyoke College Art Museum, South Hadley, Massachusetts. Gift of Mr. and Mrs. Howard P.

Vincent (Mary Wilson Smith, Class of 1926), 1988.20.12.

Auguste Bouquet, French, 1800–1846. *Dame Blanche acte II* (White Lady, act II), 1832. Lithograph, 12½ × 9 inches. *La Caricature*, No. 69, pl. 140, 23 February 1832. Mount Holyoke College Art Museum, South Hadley, Massachusetts. Purchase with Friends of Art Fund, 1989.23.4.

Auguste Bouquet, French, 1800–1846. *Ecce homo!* (Behold the Man!), 1833. Lithograph, 8¹¹⁄₁₆ × 9⅞ inches. *La Caricature*, No. 115, pl. 239, 17 January 1833. Mount Holyoke College Art Museum, South Hadley, Massachusetts. Purchase with Friends of Art Fund, 1989.23.9.

Auguste Bouquet, French, 1800–1846. *Voulez-vous aller faire vos ordures plus loin, polissons!* (Kindly take your filth elsewhere, you brats!), 1833. Lithograph, 9⅜ × 9¾ inches. *La Caricature*, No. 115, pl. 238, 17 January 1833. Mount Holyoke College Art Museum, South Hadley, Massachusetts. Gift of Mr. and Mrs. Howard P. Vincent (Mary Wilson Smith, Class of 1926), 1988.20.10.

Auguste Bouquet, French, 1800–1846. *Le Chianli crotté de toutes les manières* (The masked figure, spotted in every way), 1833. Colored Lithograph, 10¾ × 7⅝ inches. *La Caricature*, No. 223, pl. 255, 14 March 1833. Mount Holyoke College Art Museum, South Hadley, Massachusetts. Gift of Mr. and Mrs. Howard P. Vincent (Mary Wilson Smith, Class of 1926), 1988.20.7.

Auguste Bouquet, French, 1800–1846. *Les favoris de la poire* (The pear's whiskers/favorites), 1833. Colored lithograph, 9½ × 7⁹⁄₁₆ inches. *La Caricature*, No. 124, pl. 257, 21 March 1833. Mount

Holyoke College Art Museum, South Hadley, Massachusetts. Gift of Mr. and Mrs. Howard P. Vincent (Mary Wilson Smith, Class of 1926), 1988.20.11.

Auguste Bouquet, French, 1800–1846. *Exécution de Désirée Françoise Liberté (Parodie de la Jane Grey de Mr. Delaroche)* (Execution of Désirée Françoise Liberty [Parody of Jane Grey by Mr. Delaroche]), 1834. Lithograph, 9³⁄₁₆ × 13⅜ inches. *La Caricature*, No. 188, pl. 394, 13 June 1834. Mount Holyoke College Art Museum, South Hadley, Massachusetts. Gift of Mr. and Mrs. Howard P. Vincent (Mary Wilson Smith, Class of 1926), 1988.20.8.

Joseph-Gillaume Bourdet, French, 1799–1869. *On dansait au château!!!* (There was dancing at the palace!!!), 1834. Lithograph, 9¼ × 11⅛ inches. *La Caricature*, No. 173, pl. 365, 27 February 1834. Mount Holyoke College Art Museum, South Hadley, Massachusetts. Gift of Mr. and Mrs. Howard P. Vincent (Mary Wilson Smith, Class of 1926), 1991.10.4.

A. Casati, French, active 1820s and 1830s. *Parodie du tableau de la Clytemnestre* (Parody of the painting "Clytemnestra"), 1834. Lithograph, 8¼ × 8³⁄₁₆ inches. *La Caricature*, No. 168, pl. 353, 23 January 1834. Mount Holyoke College Art Museum, South Hadley, Massachusetts. Gift of Mr. and Mrs. Howard P. Vincent (Mary Wilson Smith, Class of 1926), 1991.10.1.

Honoré-Victorin Daumier, French, 1808–1879. *Encore un petit moment, je vous en prie* (Just a little bit longer, please!), August 1830. Color Lithograph, 9 × 12 inches. Lent by The Metropolitan Museum of Art, 58.512.16.

Honoré-Victorin Daumier, French, 1808–1879. *Le cauchemar* (The nightmare), 1832. Lithograph, 10⅛ × 11¹¹⁄₁₆ inches. *La Caricature*, No. 69, pl. 139, 23 February 1832. Mount Holyoke College Art Museum, South Hadley, Massachusetts. Gift of Mr. and Mrs. Howard P. Vincent (Mary Wilson Smith, Class of 1926), 1988.20.19.

Honoré-Victorin Daumier, French, 1808–1879. *Ch. de Lam . . . Ch[arles] de Lam[eth] Célébrités de la Caricature* (Ch. de Lam . . . Ch[arles] de Lam[eth] Celebrities of La Caricature), 1832. Lithograph, 12 × 8 inches. *La Caricature*, No. 78, pl. 156, 26 April 1832. Mount Holyoke College Art Museum, South Hadley, Massachusetts. Gift of Mr. and Mrs. Howard P. Vincent (Mary Wilson Smith, Class of 1926), 1991.10.7.

Honoré-Victorin Daumier, French, 1808–1879. *M. Montaugibet en pâtissier-gâte-sauce* (Mr. Montaugibet as a bad pastry chef), 1833. Lithograph, 11³⁄₁₆ × 6¹¹⁄₁₆ inches. *Le Charivari*, Bal de la Cour, No. 2, 3 February 1833. Mount Holyoke College Art Museum, South Hadley, Massachusetts. Gift of Mr. and Mrs. Howard P. Vincent (Mary Wilson Smith, Class of 1926), 1988.20.16.

Honoré-Victorin Daumier, French, 1808–1879. *Chimère de l'imagination . . . Mon dieu! Si j'allais faire un enfant à tête de Poire . . . ou bien un Lobeau . . . un d'Argout . . . un Soult . . . un Dupin ah! mon dieu!! un Kératry!!!* (Illusion of the imagination. My God! If I were to have a child with a pear's head . . . or even of a Lobeau . . . an Argout . . . a Soult . . . a Dupin . . . ah! my God!! a Kératry!!!), 1833. Lithograph, 11¼ × 7¹³⁄₁₆ inches. *La Caricature*, No. 118, pl. 244, 7 February 1833. Mount Holyoke College Art Museum, South Hadley, Massachusetts. Gift of Mr. and Mrs. Howard P. Vincent (Mary Wilson Smith, Class of 1926), 1988.20.18.

Honoré-Victorin Daumier, French, 1808–1879. **Charles Philipon**, French, 1802–1862. *Ne vous y frottez pas! (Liberté de la presse)* (Freedom of the press: do not meddle with it!), 1834. Lithograph on wove paper, 12¹⁄₁₆ × 16¹⁵⁄₁₆ inches. L'Association mensuelle, April 1834. Lent by The Metropolitan Museum of Art. Gift of Edwin De T. Bechtel, 1957, 57.650.188.

Honoré-Victorin Daumier, French, 1808–1879. **Charles Philipon**, French, 1802–1862. *Enfoncé Lafayette . . . Attrappe, mon vieux!* (Lafayette, buried! . . . that's the end of you, old fellow!), 1834. Lithograph on wove paper, 11⁷⁄₁₆ × 16³⁄₈ inches. L'Association mensuelle, 6 May 1834. Lent by The Metropolitan Museum of Art. Gift of Edwin De T. Bechtel, 1957, 57.650.190.

Honoré-Victorin Daumier, French, 1808–1879. *Pot de vin . . . arrestations arbitraires, mitraillades, transnoninades, elle couvre tout de son manteau* (Bribes, high-handed arrests, volleys of grape-shot, murderers of rue Transnonain, she covers them all with her robe), 1834. Pen lithograph, 7³⁄₁₆ × 11½ inches. *Le Charivari*, 7 September 1834. Mount Holyoke College Art Museum, South Hadley, Massachusetts. Gift of Mr. and Mrs. Howard P. Vincent (Mary Wilson Smith, Class of 1926), 1988.20.20.

Honoré-Victorin Daumier, French, 1808–1879. *François-Pierre-Guillaume Guizot*, 1832–35. Painted plaster, 8⅞ × 6⅞ × 6¹⁄₁₆ inches. The Jane Voorhees Zimmerli Art Museum, Rutgers, The State University of New Jersey. Acquired in honor of Barbara Voorhees, 2001.0382.

Honoré-Victorin Daumier, French, 1808–1879. *Pierre-Paul Royer-Collard*, 1832–35. Painted terracotta, 5½ × 4¾ × 3½ inches. The Jane Voorhees Zimmerli Art Museum, Rutgers, The State University of New Jersey. Acquired in honor of Barbara Voorhees, 2001.0387.

Honoré-Victorin Daumier, French, 1808–1879. *Charles-Malo-François, Comte de Lameth*, 1832–1835. Painted terracotta, 5¾ × 5⅝ × 3⅜ inches. The Jane Voorhees Zimmerli Art Museum, Rutgers, The State University of New Jersey, 2001.0395.

Honoré-Victorin Daumier, French, 1808–1879. *Jean-Charles Persil*, 1832–1835. Painted terracotta, 7½ × 6⅝ × 4 inches. The Jane Voorhees Zimmerli Art Museum, Rutgers, The State University of New Jersey, 2001.0404.

Honoré-Victorin Daumier, French, 1808–1879. *André-Marie-Jean-Jacques Dupin, called Dupin aîné*, 1832–35. Painted terracotta, 6 × 6 × 3⅝ inches. The Jane Voorhees Zimmerli Art Museum, Rutgers, The State University of New Jersey. Acquired in honor of Barbara Voorhees, 2001.0407.

Honoré-Victorin Daumier, French, 1808–1879. *Count Auguste-Hilarion de Kératry*, 1832–35. Painted terracotta, 5¹⁄₁₆ × 5¼ × 4⅛ inches. The Jane Voorhees Zimmerli Art Museum, Rutgers, The State University of New Jersey. Acquired in honor of Barbara Voorhees, 2001.0381.

Honoré-Victorin Daumier, French, 1808–1879. *Unidentified* (possibly Count Alfred-Frédéric-Pierre, Comte de Falloux), 1848–1850. Painted terracotta, 9 × 5½ × 5⅜ inches. The Jane Voorhees Zimmerli Art Museum, Rutgers, The State University of New Jersey, 2001.0375.

Auguste Desperret, French, d. 1865. *Untitled (Un Chiffonnier et quelqu'un se donnant une poignée de mains* [A ragpicker and someone shaking hands]), 1832. Lithograph, 10¼ × 7¼ inches. *La Caricature*, No. 100, pl. 204, 4 October 1832. Mount Holyoke College Art Museum, South Hadley, Massachusetts. Gift of Mr. and Mrs. Howard P. Vincent (Mary Wilson Smith, Class of 1926), 1988.20.3.

Auguste Desperret, French, d. 1865. *Bravo! Tous les coups portent* (Bravo! Every shot strikes home), 1833. Lithograph, 9¼ × 9¼ inches. *La Caricature*, No. 114, pl. 237, 10 January 1833. Mount Holyoke College Art Museum, South Hadley, Massachusetts. Purchase with Friends of Art Fund, 1989.23.7.

Auguste Desperret, French, d. 1865. *Mes camarades, mes cher camarades ! . . . je suis aussi / républicain que vous . . . j'aime la liberté . . . l'égalité . . . je / veux votre bien . . . Votre bien à tous . . . le bien de tout le monde* (My comrades, my dear comrades! . . . I am as much of a republican as you are . . . I love liberty . . . equality . . . I want the best for you . . . the best for everyone . . . the best for the whole world), 1833. Lithograph, 9⅞ × 7¼ inches. *La Caricature*, No. 120, pl. 249, 21 February 1833. Mount Holyoke College Art Museum, South Hadley, Massachusetts. Gift of Mr. and Mrs. Howard P. Vincent (Mary Wilson Smith, Class of 1926), 1988.20.1.

Auguste Desperret, French, d. 1865. *Untitled (Louis Philippe, en géôlier à cheval sur trois cages, "Ste. Pélagie," "La Force," "Blaye"* [Louis Philippe as a jailer straddling three cages, Ste. Pelagie, La Force, Blaye]), 1833. Colored lithograph, 11³⁄₁₆ × 8⅞ inches. *La Caricature*, No. 129, pl. 267, 25 April 1833. Mount Holyoke College Art Museum, South Hadley, Massachusetts. Gift of Mr. and Mrs. Howard P. Vincent (Mary Wilson Smith, Class of 1926), 1988.20.23.

Auguste Desperret, French, d. 1865. *Untitled* (Louis-Philippe studying the plans of Paris), 1833. Lithograph, 8⅞ × 7⁷⁄₁₆ inches. *La Caricature*, No. 147, pl. 307, 29 August 1833. Mount Holyoke College Art Museum, South Hadley, Massachusetts. Purchase with Friends of Art Fund, 1989.23.6.

Auguste Desperret, French, d. 1865. *Tonneau des Danaïdes* (The Danaïdes'

Barrel), 1833. Lithograph, 8⅜ × 11 inches. *Le Charivari*, Série polit. 141, 18 December 1833. Mount Holyoke College Art Museum, South Hadley, Massachusetts. Gift of Mr. and Mrs. Howard P. Vincent (Mary Wilson Smith, Class of 1926), 1998.20.05.

Eugene-Hippolyte Forest, French, b. 1808, active until ca. 1866. *L'Angleterre, la Russie, l'Autriche et la Prusse me donnent toujours des temoignages de leur parfaite alliance . . .* (England, Russia, Austria, and Prussia always assure me of their perfect alliance . . .), 1834. Lithograph, 9⅝ × 13¹⁄₁₆ inches. *La Caricature*, No. 168, pl. 54, 23 January 1834. Mount Holyoke College Art Museum, South Hadley, Massachusetts. Gift of Marie-Rose Carre, 1991.14.

Jean Jacques Grandville, French, 1803–1847. *Le Ministère attaqué de choléra-morbus* (The ministry attacked by cholera morbus) (Pear cat. No. 37), 1831. Pen lithograph, 9⅛ × 11 inches. *La Caricature*, No. 40, pl. 79, 4 August 1831. Mount Holyoke College Art Museum, South Hadley, Massachusetts. Gift of Mr. and Mrs. Howard P. Vincent (Mary Wilson Smith, Class of 1926), 1988.20.27.

Jean Jacques Grandville, French, 1803–1847. *Encore une fois, Madame, voulez vous ou ne voulez vous pas divorcer, vous êtes parfaitment libre* (One more time, Madame, do you or do you not wish to divorce, you are perfectly free), 1832. Lithograph, 7½ × 9⅛ inches. Lent by the Metropolitan Museum of Art, The Elisha Whittelsey Collection, The Elisha Whittelsey Fund, 1963, 63.625.100.

Jean Jacques Grandville, French, 1803–1847. **Charles Philipon**, French, 1802–1862. **Denis Auguste Marie Raffet**, French, 1804–1860. *Sur mon honneur et sur ma conscience* (On my honor and on my conscience), 1832. Lithograph on chine collée, 9½ × 14⅜ inches. L'Association mensuelle, September 1832.

Lent by The Metropolitan Museum of Art, Gift of Edwin De T. Bechtel, 1957, 57.650.623(2).

Jean Jacques Grandville, French, 1803–1847. **Eugene-Hippolyte Forest**, French, b. 1808, active until ca. 1866. *Ils ne savent plus à quel saint se vouer* (They no longer know to which saint they should be dedicated), 1832. Lithograph, 11⅝ × 14¾₁₆ inches. *La Caricature*, 18 October 1832. Mount Holyoke College Art Museum, South Hadley, Massachusetts. Gift of Mr. and Mrs. Howard P. Vincent (Mary Wilson Smith, Class of 1926), 1988.20.29.

Jean Jacques Grandville, French, 1803–1847. **Eugene-Hippolyte Forest**, French, b. 1808, active until ca. 1866. *Enlève-ment des boues de Paris* (Removing mud from Paris), 1832. Lithograph, 11⅝ × 8¼ inches. *La Caricature*, No. 103, pl. 211, 25 October 1832. Mount Holyoke College Art Museum, South Hadley, Massachusetts. Purchase with Friends of Art Fund, 1989.23.5.

Jean Jacques Grandville, French, 1803–1847. **Charles Philipon**, French, 1802–1862. **Denis Auguste Marie Raffet**, French, 1804–1860. *Le Peuple livré aux impôts* (The people delivered to taxes), 1833. Lithograph on wove paper, 9⅛ × 13⁵⁄₁₆ inches. L'Association mensuelle, May 1833. Lent by the Metropolitan Museum of Art, New York. Gift of Edwin De T. Bechtel, 1957, 57.650.623(11).

Jean Jacques Grandville, French, 1803–1847. *Imitation libre d'un tableau de M. Horace Vernet représentant le massacre des Janissaires* (Free imitation of a painting by M. Horace Vernet depicting the massacre of the Janissaires), 1834. Lithograph, 10⅞ × 14⅝ inches. *La Caricature*, No. 179, pl. 376 and 377, 10 April 1834. Mount Holyoke College Art Museum, South Hadley, Massachusetts. Gift of Mr. and Mrs. Howard P. Vincent (Mary Wilson Smith, Class of 1926), 1988.20.31.

Jean Jacques Grandville, French, 1803–1847. **Eugene-Hippolyte Forest**, French, b. 1808, active until ca. 1866. *Untitled (Le Jongleur, sauteur, banquiste et prestidigitateur [The juggler, unreliable fellow, charlatan, and magician])*, 1835. Pen lithograph, 8¹³⁄₁₆ × 10⅞ inches. *La Caricature*, No. 224, pl. 467, 5 May 1835. Mount Holyoke College Art Museum, South Hadley, Massachusetts. Gift of Mr. and Mrs. Howard P. Vincent (Mary Wilson Smith, Class of 1926), 1988.20.26.

Jean Paul, French, 19th Century. *C'est le peuple qui porte tout* (It is the people who carry everything), 19th century. Lithograph, 12³⁄₁₆ × 9⁹⁄₁₆ inches. Lent by The Metropolitan Museum of Art, Gift of Weston J. Naef, 1985, 1985.1123.102.

Charles Philipon, French, 1802–1862. *Le Replâtrage* (Replastering), 1831. Lithograph, 12 × 9⅛ inches. *La Caricature*, No. 35, pl. 70, 30 June 1831. Mount Holyoke College Art Museum, South Hadley, Massachusetts. Gift of Mr. and Mrs. Howard P. Vincent (Mary Wilson Smith, Class of 1926), 1991.10.3.

Charles Philipon, French, 1802–1862. *Croquades faites à l'audience du 14 novembre Cour d'Assises* (Sketches made at the hearing on 14 November, Court of Assizes), 1831. Pen lithograph, 13⅜ × 9⅝ inches. *La Caricature*, No. 56, Supplement, 24 November 1831. Mount Holyoke College Art Museum, South Hadley, Massachusetts. Gift of Mr. and Mrs. Howard P. Vincent (Mary Wilson Smith, Class of 1926), 1988.20.39.

Benjamin Roubaud, French, 1811–1847. *Grrrrrrrandes Manoeuvres exécutées sur les Montagnes de la Biscaye; par les deux vaillantes armées de Rodil et de Zumalac-arrequi* (Great maneuvers carried out in the Biscay mountains by the two valiant armies of Rodil and Zumalacarrequi), 1834. Lithograph, 13⅜ × 16½ inches. *La Caricature*, 9 October 1834. Mount Holyoke College Art Museum, South

Hadley, Massachusetts. Gift of Mr. and Mrs. Howard P. Vincent (Mary Wilson Smith, Class of 1926), 1991.10.6.

Charles Joseph Traviès de Villiers, French (born in Switzerland), 1804–1859. *Faut avouer que l'gouvernement a une bien [sic] drôle de tête* (You've got to admit that the government has a funny-looking head), 1831. Lithograph, 7⅝ × 10¹³⁄₁₆ inches. *La Caricature*, 22 December 1831. Lent by the Metropolitan Museum of Art, The Elisha Whittelsey Collection, The Elisha Whittelsey Fund, 1996, 66.559.25.

Charles Joseph Traviès de Villiers, French (born in Switzerland), 1804–1859. *Ah! Scélérate de poire pourquoi n'es tu pas une vérité!* (Ah! Villainous pear, why are you not a truth!), 1832. Colored Lithograph, 10¼ × 6⅝ inches. *La Caricature*, No. 76, pl. 153, 12 April 1832. Mount Holyoke College Art Museum, South Hadley, Massachusetts. Gift of Mr. and Mrs. Howard P. Vincent (Mary Wilson Smith, Class of 1926), 1988.20.43.

Charles Joseph Traviès de Villiers, French (born in Switzerland), 1804–1859. *1834*, 1833. Lithograph, 9¹¹⁄₁₆ × 11 inches. *La Caricature*, No. 139, pl. 289, 4 July 1833. Mount Holyoke College Art Museum, South Hadley, Massachusetts. Gift of Mr. and Mrs. Howard P. Vincent (Mary Wilson Smith, Class of 1926),1988.20.04.

Charles Joseph Traviès de Villiers, French, (born in Switzerland), 1804–1859. *Décidément! L'arbre est pourri, il n'y pas une branche de bonne* (Most assuredly! The tree is rotten, there isn't even one good branch), 1833. Lithograph, 9⁵⁄₁₆ × 10⅜ inches. *La Caricature*, No. 150, pl. 313, 19 September 1833. Mount Holyoke College Art Museum, South Hadley, Massachusetts. Gift of Mr. and Mrs. Howard P. Vincent (Mary Wilson Smith, Class of 1926), 1988.20.2.

Charles Joseph Traviès de Villiers, French (born in Switzerland), 1804–1859. *Voici, Messieurs, ce que nous avons l'honneur d'exposer journellement. Si vous êtes contens et satisfaits faites en part à vos amis et connaissances. On ne paye qu'en s'abonnant et il faudrait vraiment ne pas avoir 13f dans sa poche pour se priver de voir cette magnifique collection qui fait tous les jours l'amusement du Roi et de son Auguste famille. zin . . . baound!* (Here, gentlemen, is what we have the honor of showing every day. If you are pleased and satisfied, take part in it with your friends and acquaintances; you don't have to pay until you subscribe and you need to have only 13 francs in your pocket to be privileged to see this magnificent collection, which amuses the king, as well as his august family, every day), 1834. Lithograph, 12¾ × 16¹⁵⁄₁₆ inches. *La Caricature*, No. 174, pl. 366 and 367, 6 March 1834. Mount Holyoke College Art Museum, South Hadley, Massachusetts. Gift of Mr. and Mrs. Howard P. Vincent (Mary Wilson Smith, Class of 1926), 1988.20.41.

Charles Joseph Traviès de Villiers, French (born in Switzerland), 1804–1859. *Festin de Balthazar* (Belshazzar's Feast), 1834. Lithograph, 11¼ × 14 inches. *La Caricature*, No. 181, pl. 380 and 381, 24 April 1834. Mount Holyoke College Art Museum, South Hadley, Massachusetts. Gift of Mr. and Mrs. Howard P. Vincent (Mary Wilson Smith, Class of 1926), 1988.20.46

Charles Joseph Traviès de Villiers, French (born in Switzerland), 1804–1859. *Quel rêve! . . . il disait que des prisonniers sans défense des blessés, des mutilés, des enfans avaient été assassinés . . . il disait qu'on avait même fusillé un demi-cadavre flottant dans la rivière . . . il disait: vous arrosez l'arbre de la discorde avec les flots de sang, vous le fumez de chair humaine . . . mais c'était un rêve, une erreur, un mensonge, ils l'ont condamné comme . . . Calomniateur . . . Calomniateur!!!!* (Some dream! It said that defenseless prisoners, some wounded, some crippled, and some children had been murdered . . . it said that they even shot a half-dead body floating in the river . . . it said: you water the tree of discord with waves of blood, you fertilize it with human flesh . . . but it was a dream, an error, a lie, they have condemned it as . . . Liar . . . Liar!!!!), 1834. Lithograph, 11⅛ × 13⅝ inches. *La Caricature*, No. 190, pl. 398 and 399, 24 June 1834. Mount Holyoke College Art Museum, South Hadley, Massachusetts. Gift of Mr. and Mrs. Howard P. Vincent (Mary Wilson Smith, Class of 1926), 1988.20.45.

Caricature & the Contemporary Presidency

Nick Anderson, American, b. 1956. *Wilting in the Heat*, 2008. Digital print. *The Houston Chronicle*, 22 July 2008. Courtesy of Nick Anderson/The Houston Chronicle.

Steve Bell, British, b. 1951. *Bush Throat Job*, 2003. Watercolor, pen, and ink on watercolor paper, 9 × 12 inches. *The Guardian*, 16 December 2003. Courtesy of Steve Bell.

Steve Bell, British, b. 1951. *Yellow Cake Road*, 2004. Watercolor, pen, and ink on watercolor paper, 9 × 12 inches. *The Guardian*, 21 January 2004. Courtesy of Steve Bell.

Steve Bell, British, b. 1951. *Al Who'da??* 2004. Watercolor, pen, and ink on watercolor paper, 9 × 12 inches. *The Guardian*, 24 March 2004. Courtesy of Steve Bell.

Steve Bell, British, b. 1951. *The Ascent of the Chimp Part 2*, 2006. Watercolor, pen, and ink on watercolor paper, 9 × 12 inches. *The Guardian*, 9 November 2006. Courtesy of Simon M. Powell.

Steve Bell, British, b. 1951. *Iraq Contracts*, 2008. Watercolor, pen, and ink on watercolor paper, 9 × 12 inches. *The Guardian*, 1 July 2008. Courtesy of Steve Bell.

Khalil Bendib, Algerian-American, b. 1959. *You Guys Ever Heard of Toilet Paper*, 2007. Pen and ink on paper with Photoshop finishing, 9 × 12 inches. *Muslim Observer*, 2007; also in *Mission Accomplished: Wicked Cartoons by America's Most Wanted Political Cartoonist* (Northampton, MA: Interlink Books, 2007), p. 104. Courtesy of Khalil Bendib.

Ruben Bolling (Ken Fisher), American, b. 1962. *King George, from Tom the Dancing Bug*, 2007. Pen and ink on bristol board, color finishing on computer; two pieces: 11 × 14 and 8½ × 11 inches respectively. *The Village Voice*, 24 June 2007. Courtesy of Ruben Bolling.

Steve Brodner, American, b. 1954. *Clinton Illustrated*, 1996. Watercolor, 15 × 20 inches. *Mother Jones*, 1996. Courtesy of Steve Brodner.

Steve Brodner, American, b. 1954. *Bush Horse*, 1998. Watercolor, 15 × 20 inches. *Esquire*, October 1998. Courtesy of Steve Brodner.

Steve Brodner, American, b. 1954. *The Bushanos*, 2003. Watercolor, 15 × 20 inches. *The Nation*, 2004. Courtesy of Steve Brodner.

Joe Ciardiello, American, b. 1953. *Dick and Dummy*, 2007. Pen and ink, 15½ × 20½ inches framed. *"Artists Against the War,"* Society of Illustrators, New York, New York, January 2008. Courtesy of Joe Ciardiello.

John Cuneo, American. *Bush's Final F. U.*, 2008. Ink and watercolor, 8½ × 7 inches. *Rolling Stone*, 25 December 2008. Courtesy of John Cuneo.

Jeff Danziger, American, b. 1943. *The Case for Impeachment*, 2007. Ink with computer finishing, 11 × 17 inches. *The New York Times*, 20 August 2007. Courtesy of Jeff Danziger/New York Times Syndicate.

Matt Davies, British-American, b. 1966. *We've Rounded a Corner (Bush and Uncle Sam in a Maze)*, 2008. Pen and ink on bristol paper, 11 × 14 inches. *The Journal News*, 29 January 2008. Courtesy of Matt Davies.

Mr. Fish (Dwayne Booth), American, b. 1966. *George Bush in the Oval Office Watching Karl Rove Leave the White House*, 2007. Graphite on paper, 8½ × 11 inches. *Harper's Magazine*, 17 August 2007. Courtesy of Mr. Fish.

Nicholas Garland, British, b. 1935. *America's Nightmare—after Fuseli*, 2006. Pen, ink, and watercolor, 10⅜ × 7⅞ inches. *The Daily Telegraph*, London, 16 February 2006. Courtesy of Nicholas Garland.

Nicholas Garland, British, b. 1935. *9.11.2007*, 2007. Pen, ink and watercolor, 13 × 9 inches. *The Daily Telegraph*, London, 9 November 2007. Courtesy of Nicholas Garland.

Kevin KAL Kallaugher, American, b. 1955. *Clinton Temptations*, 1998. Pen, brush, gouache, and India ink, 15½ × 15½ inches. *The Economist* (cover), 24–30 January 1998. Courtesy of Kevin KAL Kallaugher.

Kevin KAL Kallaugher, American, b. 1955. *Florida*, 2000. Pen, brush, and India ink, 18 × 18 inches. *The Economist*, 11 November 2000. Courtesy of Kevin KAL Kallaugher.

Kevin KAL Kallaugher, American, b. 1955. *BLT . . . WMD*, 2004. Pen, brush, and India ink, 16 × 20 inches. *The Economist*, 17 July 2004. Courtesy of Kevin KAL Kallaugher.

Kevin KAL Kallaugher, American, b. 1955. *Dubya or Bust*, 2006. Plastellina, 14 × 14 × 14 inches, approx. Courtesy of Kevin KAL Kallaugher.

Kevin KAL Kallaugher, American, b. 1955. *Bush Walks (Dancin' Dubya)*, 2008. Digital animation. *http://www.kaltoons. com*, 2008. Courtesy of Kevin KAL Kallaugher.

Peter Kuper, American, b. 1958. *Ceci n'est pas une comic*, 2008. Silkscreen, 15 × 20 inches. *Nozone*, 2008. Courtesy of Peter Kuper.

Liz Lomax, American, b. 1975. *Oh No You Don't*, 2004. Digital photography and composite, 11½ × 16⅜ inches. *The Weekly Standard*, 6 September 2004. Courtesy of Liz Lomax.

Liz Lomax, American, b. 1975. *Bailout*, 2009. Oil on Super Sculpey, armature wire, and tinfoil, 2 × 3 × 2 inches, 4 × 4 × 2 inches, and 4 × 3½ × 2½ inches. Courtesy of Liz Lomax.

Liz Lomax, American, b. 1975. *Bailout*, 2009. Pencil on paper, 8¼ × 10 inches. Courtesy of Liz Lomax.

Liz Lomax, American, b. 1975. *Bailout*, 2009. Giclee print, 17 × 21 inches. *The Wall Street Journal*, 2 January 2009. Courtesy of Liz Lomax.

Stephanie McMillan, American, b. 1965. *Minimum Security: Surrounded*, 2003. Pen and ink on paper, 6½ × 8½ inches on 8½ × 11-inch paper. *Z Magazine*, 2003. Courtesy of Stephanie McMillan.

Pat Oliphant, Australian, b. 1934. *Iraq Pietà*, 2004. Pen and India ink on archival hot press paper, 11 × 14 inches. Syndicated, 12 July 2004. Courtesy of Susan Conway Gallery, Santa Fe, New Mexico, and Washington, D.C.

Pat Oliphant, Australian, b. 1934. *On the Road*, 2005. Pen and India ink on archival hot press paper, 11 × 14 inches. Syndicated, 23 August 2005. Courtesy of Susan Conway Gallery, Santa Fe, New Mexico, and Washington, D.C.

Pat Oliphant, Australian, b. 1934. *Bush & Co. Demolition*, 2008. Pen and India ink on archival hot press paper, 11 × 14 inches. *International Herald Tribune*, 23 September 2008. Courtesy of Susan Conway Gallery, Santa Fe, New Mexico, and Washington, D.C.

Roberto Parada, American, b. 1969. *Up in Smoke*, 2005. Acrylic and charcoal pencils, 15 × 19 inches. *The Nation*, May 2005. Courtesy of Roberto Parada.

Chris Payne, American, b. 1954. *Clinton Wooing the Black Vote*, 1992. Oil, acrylic, watercolor, ink, and colored pencil on cold press illustration board, 15 × 20 inches. *The Source*, 1992. Courtesy of C. F. Payne.

Drexel Dwane Powell, American, b. 1944. *The Men Behind the Curtain*, 2008. 13 × 9 inches. *The News and Observer*, 1 June 2008. Courtesy of Drexel Dwane Powell.

Ted Rall, American, b. 1963. *A Cabinet that Looks Like America*, 2000. Black and white line art, 8½ × 11 inches. *Generalissimo el Busho*, 26 December 2000. Courtesy of Ted Rall, Universal Press Syndicate.

Ted Rall, American, b. 1963. *Crisis! How Bush Responds*, 2005. Black and white line art, 8½ × 11 inches. *Generalissimo el Busho*, 12 September 2005. Courtesy of Ted Rall, Universal Press Syndicate.

Lynn Randolph, American, b. 1938. *The Coronation of Saint George*, 2004. Oil on canvas, 48 × 36 inches. *The Nation* (cover), 14 September 2004. Courtesy of Richard and Janet Caldwel.

Rob Rogers, American. *Iraq Forced Me to Give Up Golf Too*, 2008. Ink on Grafix 32-L Unishade Board, 12¾ × 9 inches. *Pittsburgh Post-Gazette*, 20 May 2008. Courtesy of Rob Rogers/*Pittsburgh Post-Gazette*.

Martin Rowson, British, b. 1959. *Vote Early, Vote Often*, 2006. Gouache, 8 × 11 inches. *The Guardian*, 7 November 2006. Courtesy of Martin Rowson and Guardian News and Media Archive, United Kingdom.

Martin Rowson, British, b. 1959. *Wolf, Wolf*, 2007. Gouache, 8½ × 11 inches. *The Guardian*, 13 February 2007. Courtesy of Martin Rowson and Guardian News and Media Archive, United Kingdom.

Gerald Scarfe, British, b. 1936. *Clintocchio—Been Telling Lies Again*, 1998. Pen, ink, and watercolor, 33 × 23 inches. *The Sunday Times*, 1998. Courtesy of Gerald Scarfe.

Gerald Scarfe, British, b. 1936. *Looking for Osama*, 2001. Pen, ink, and watercolor, 33 × 23 inches. *The Sunday Times, 2001*. Courtesy of Gerald Scarfe.

Gerald Scarfe, British, b. 1936. *How the Hell Did That Get Here?* 2004. Pen, ink, and watercolor, 33 × 23 inches. *The Sunday Times*, 2004. Courtesy of Gerald Scarfe.

Gerald Scarfe, British, b. 1936. *My Election Chances*, 2004. Pen, ink, and watercolor, 33 × 23 inches. *The Sunday Times*, 2004. Courtesy of Gerald Scarfe.

Edward Sorel, American, b. 1929. *Privatization Orgy*, 2007. Pen, ink, and watercolor, 21⅛ × 14⅞ inches. *Vanity Fair*, June 2007. Courtesy of Edward Sorel.

Edward Sorel, American, b. 1929. *In Clods We Trust*, 2007. Pen, ink, and watercolor, 20 × 16 inches. *Rolling Stone*, 29 June 2006. Courtesy of Edward Sorel.

Edward Sorel, American, b. 1929. *Grand Delusion*, 2007. Pen, ink, and watercolor, 22½ × 16 inches. *Vanity Fair*, August 2007. Courtesy of Edward Sorel.

Edward Sorel, American, b. 1929. *Running on Empty*, 2008. Grease pencil, thinner, and watercolor, 22⅞ × 16¼ inches. *Vanity Fair*, April 2008. Courtesy of Edward Sorel.

Ward Sutton, American, b. 1966. *One Day It Will Hit Him*, 2001. Digital print made with ink on paper with computer finishing. *The Village Voice*, 2001. Courtesy of Ward Sutton.

Tom Tomorrow (Dan Perkins), American, b. 1961. *Farewell to Bush (Shower of Shoes)*, 2009. Digital print. *This Modern World*, 21 January 2009. Courtesy of Tom Tomorrow.

Garry Trudeau, American, b. 1948. *Doonesbury Daily Strip*, 2001. Pen and ink, 7 × 17 inches. Syndicated, 6 August 2001. Courtesy of Garry Trudeau.

Garry Trudeau, American, b. 1948. *Doonesbury Daily Strip*, 2001. Pen and ink, 7 × 17 inches. Syndicated, 8 August 2001. Courtesy of Garry Trudeau.

Garry Trudeau, American, b. 1948. *Doonesbury Daily Strip*, 2001. Pen and ink, 7 × 17 inches. Syndicated, 9 August 2001. Courtesy of Garry Trudeau.

Garry Trudeau, American, b. 1948. *Doonesbury Daily Strip*, 2001. Pen and ink, 7 × 17 inches. Syndicated, 10 August 2001. Courtesy of Garry Trudeau.

Garry Trudeau, American, b. 1948. *Doonesbury Sunday Strip*, 2001. Pen and ink, 16 × 23 inches. Syndicated, 18 November 2001. Courtesy of Garry Trudeau.

Mark Ulriksen, American, b. 1957. *Watch Your Back Mountain*, 2006. Acrylic on paper, 16 × 12 inches. *The New Yorker* (cover), 27 February 2006. Courtesy of Mark Ulriksen.

Gary Varvel, American, b. 1957. *Which Suit Most Offends Democrats?* 2003. India ink on drawing bristol, 11 × 7½ inches. *The Indianapolis Star*, 9 May 2003. Courtesy of Gary Varvel/*The Indianapolis Star.*

Lines of Attack